MW00358591

IMAGES
of America

TENAFLY

On the cover: In this 1936 photograph, several Tenafly High School students wait for the train to take them north to their neighboring towns. The station was just a short walk of a couple of blocks from the school. (Courtesy of the Tenafly Historic Archives Collection, Tenafly Public Library.)

IMAGES
of America

TENAFLY

Alice Renner Rigney
and Paul J. Stefanowicz

ARCADIA
PUBLISHING

Copyright © 2009 by Alice Renner Rigney and Paul J. Stefanowicz
ISBN 978-1-5316-4044-6

Published by Arcadia Publishing
Charleston, South Carolina

Library of Congress Control Number: 2008935738

For all general information contact Arcadia Publishing at:
Telephone 843-853-2070
Fax 843-853-0044
E-mail sales@arcadiapublishing.com
For customer service and orders:
Toll-Free 1-888-313-2665

Visit us on the Internet at www.arcadiapublishing.com

Dedicated to the early pioneers and the founding fathers of Tenafly, to the generations who stayed and raised their families here, to those who care enough to come back year after year to celebrate at reunions, and most of all, to those who strive to preserve the past for the future

CONTENTS

ACKNOWLEDGMENTS

It all began with an innocent suggestion from Bob Kutik, owner of Womrath's Book Store, that I do a book about Tenafly. Without a second thought, my reply was "sure." So here we are almost two years later—finally, the book called *Tenafly*. This could never have been accomplished without the help and right hand of Paul J. Stefanowicz, who gave of his time, writing talents, knowledge of the computer, and organizational skills, all done with great patience and good humor for his love of Tenafly.

—Alice Renner Rigney

I am grateful to Alice Renner Rigney for kindly opening the doors of Tenafly history and allowing me to help on this project. The time spent doing this book with her has been priceless in my learning experience and has greatly enhanced my appreciation of Tenafly's history and good people. I also thank my mother and father, Mr. and Mrs. Joseph Stefanowicz, for making this all possible; Prof. Richard N. Juliani of Villanova University for his years of example, advice, and encouragement; Josephine Yuresko, my 11th-grade history teacher at Tenafly High School, whose style both informed as well as inspired me to learn more about U.S. history; and, of course, my wife, Joanne, for encouraging me in this project and in everything that is important in life.

—Paul J. Stefanowicz

Together we are appreciative of the following people for their generous donations of pictures or information: John Barrett; Charlotte Westervelt Bispham; Karen Boyan, historian of the Presbyterian Church at Tenafly; Carol Byrne; Al Cafiero; George Carter and the Tenafly Public Library; Athena Chagaris; Mary Anne Mugler Coffey; Lynne Pendergast Ferdon; Jim Foxen; Bob Fuller; Helen and Bud Giordano; Ashbel Green; Ashbel "Tony" Green; Irmgard Merk Hartung; Noel Haskell; the Library of Congress; Melissa Lyons-Goetz; Roger Markay; John McNamara; Rosemarie and Don Merino; Ellie and Edward Mildenberger; John Minke; Helen Moore; Virginia Mosley, former borough historian; Suzanne Mugler; Karen Neus; Norbert Pendergast III; Charles Price; Ray Rancan; Sasha Ressetar; Margaret Robbiano; Barea Lamb Seeley; Janet and Paul Semendinger; Nicholas Stefanowicz; Tom Swift; Richard Trebino; Dave Wall; Bob Ward; Bill Westervelt; Joyce and Donald Zeiller; and Angie Curione Zwisler.

Unless otherwise noted, all images appear courtesy of the Tenafly Historic Archives Collection at the Tenafly Public Library.

INTRODUCTION

The exact origin of the name Tenafly is often disputed. However, one viable version is that the name derived from the Dutch word for willow meadow. Early Tenafly was a picturesque combination of farmland and rocky terrain, with several swampy areas and brooks running throughout. It was largely populated by people of Dutch or Huguenot descent. Local farmers of the 18th century were able to take their goods to New Amsterdam (New York City) from Huyler's Landing by way of rowboats. Along the Palisades, the town reaches an elevation of 400 feet above sea level, and near the railroad tracks, the elevation is merely 30 feet above sea level.

The Tenafly (Tienevly) area that appears on J. W. Watkins's Revolutionary War–era map of 1778 shows a handful of houses along County and Tenafly Roads, one of which, the Roelof Westervelt house, still stands today. Much of the land was part of the Van Cortlandt patent, granted in the 17th century, which passed into the Jay family by way of marriage. Peter Jay inherited these tracts from his father, Sir James Jay, who was the brother of the Supreme Court chief justice John Jay. In 1829, Peter Jay decided to part with the land, so a lottery was held. Many large lots were purchased for investment purposes, but overall, the lottery was not successful, as Tenafly was not accessible enough for wide-scale development at that point.

By 1859, when the Northern Railroad came to town, the village began to take shape. The railroad station, designed by Daniel T. Atwood, was built in 1872. A trolley service later began in 1910 and took passengers to Jersey City. Once the village was more convenient for city dwellers, the population began to grow rapidly. Wealthy businessmen, many of whom were connected to the burgeoning railroad business, began building estates and moving to Tenafly in the 1880s. Others moved out from New York City. While in 1890, the population of Tenafly was 1,046, it would grow to 3,585 by 1920. As more people came to town, the need for infrastructure grew, and the town began to resemble the community of today. In 1871, the village of Tenafly became part of Palisades Township, formed from the Hackensack Township that was created in 1693.

In 1894, Tenafly gained independent status as a borough, with an area of four square miles, by a narrow vote of 137–130. The important vote was held in Watson's Row, a group of stores that stood on Highwood Avenue. By incorporating as a borough, Tenafly would gain ability to use taxes for its own local use without falling under the umbrella of a township's decisions. The first mayor of Tenafly was Henry Palmer, who was an executive of a dye company. Once the George Washington Bridge became a reality in 1931, and the former large estates were turned into residential development, the population of the borough increased sharply, reaching beyond 14,000 for the first time in the 1950s.

Until 1870, Tenafly children attended school at the Liberty Pole School in Englewood. In 1871, a new school was built by the community on the corner of West Clinton Avenue and Tenafly Road. This was the lone school in town until 1907, when the Browning School was built to the east along West Clinton Avenue. The Browning School curriculum ran until eighth grade; those students who continued their education further went to school in Englewood. A high school was eventually added to the Browning grammar school, with classes beginning in 1922. Ralph S. Maugham was chosen as principal of the school in 1887, and eventually a second grammar school was erected on Magnolia Avenue bearing his name. As the town developed, the school system grew until four elementary schools—named Maugham, Mackay, Stillman, and Smith after prominent residents—were joined by middle and high schools.

The oldest congregation of worship in Tenafly is the Presbyterian Church, which was formally organized in 1865. The Episcopal Church was organized shortly after the Civil War, and services for Mount Carmel Roman Catholic Church began in 1873. Grace Chapel was started in 1899, while the Methodist Church was instituted in 1909. Today many religious denominations are represented in Tenafly.

Early on, Tenafly was serviced by a mostly volunteer police force under the marshal system. The police department was officially organized in 1918 under Chief George McLaughlin. Chester (Chet) Campbell ably handled these duties from the 1930s through the 1960s. The original firehouse stood on West Clinton Avenue near Franklin Street before ultimately moving to the borough hall building on Washington Avenue in 1913. The fire department was founded in 1891 under Chief George H. Westervelt, but the first fire on record in Tenafly occurred in a barn in 1778. Hundreds of residents have heroically served in the armed forces during conflict, with 37 having given their lives for their country.

The Tenafly Library Association was formed in 1891, bringing Tenafly a literary influence in the form of a reading room. After using the top floor of the school building since 1909, the library opened in its own building on the south side of Washington Avenue in 1912. The first town newspaper, the *Tenafly Record*, was organized and edited by William Jellison in 1884. Later newspapers, such as the *Northern Valley Tribune*, were printed in a building on West Clinton Avenue next to the school.

Some well-known Americans lived in Tenafly during its formative years. Thomas James, postmaster under Pres. James Garfield, and suffragist Elizabeth Cady Stanton owned homes in Tenafly in the late 1800s. Stanton made history in 1880 when she attempted to vote at Tenafly's Valley Hotel, now the location of Charlie Brown's Steakhouse. Musician and bandleader Glenn Miller lived in an apartment in Tenafly in the late 1930s and into the 1940s.

In 1889, water mains were installed in Tenafly. Electric lighting appeared in 1900, gas mains arrived in 1904, and telephones came to residences in 1919. A sewer system was laid out in 1927, after much debate; many of the roads in town were finally paved at that time. Houses were first numbered in 1922 after home mail delivery began in 1920. Previously, mail could be picked up several times a day at the original post office at the Tenafly depot or later in locations that stood at the corners of Washington and Railroad Avenues.

The downtown grew to serve the changing needs of Tenafly's residents. In the 1880s, there were only handfuls of free-standing frame shops, but by the early 1920s, Tenafly's Railroad Avenue retail district had, for the most part, grown into what it looks like today. Washington Avenue was originally a tree-lined dirt road with a few food markets, a pharmacist, a livery stable, and a clothing store. It eventually became more complex and now serves the banking, shopping, and dining needs of a town of almost 15,000 people. The real estate business developed in town as the borough did, with homes always in demand in this scenic town known for its excellent school system.

Tenafly's history is in its people, homes, and schools, as well as its civic, religious, and social institutions. This volume hopes to bring readers a flavor, through photographs, of what made Tenafly great in decades past and how it became the town it is today.

One

LIFE AND PEOPLE

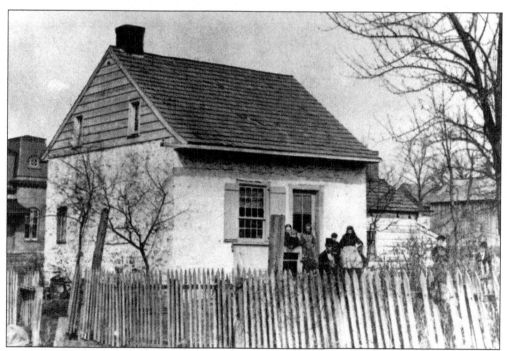

Sarah Bogert, known as Sally, married David Campbell. They moved from Park Ridge and settled in Tenafly in a house on the southeast corner of Tenafly Road and East Clinton Avenue across from the first public school in Tenafly (built in the early 1870s). They are buried in the Old South Church Cemetery in Bergenfield.

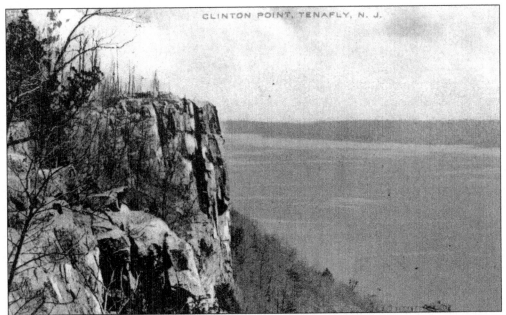

Clinton Point on the Tenafly Palisades was a favorite picnic spot before the Palisades Interstate Parkway was built and when Route 9W was still a dirt road. The section along the river in Tenafly has been designated as a national historic landmark. Stone quarrying in the early 1900s threatened the magnificent Palisades. The efforts of the local woman's club managed to preserve the cliffs by having quarrying outlawed.

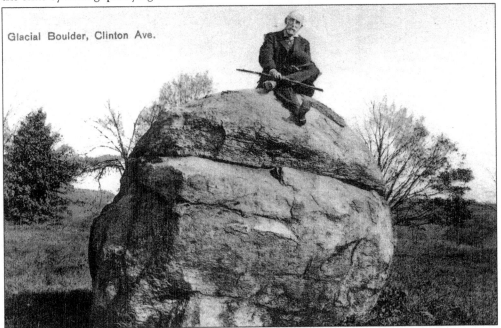

Haring Rock, a glacial boulder, was found a few hundred feet north of East Clinton Avenue high upon the westerly slope of the Palisades. It stood on a narrow base upon a solid stratum of traprock. It is 12 feet high and weighs between 8 and 15 tons. In 1979, the rock was moved to the Tenafly Nature Center Preserve.

This was the house of Peter D. Westervelt on Tenafly Road. He was born in 1799 across the way in the old Westervelt homestead. He built this house about 1870, wanting it to overlook the old Westervelt homestead. He was the father of Andrew H. Westervelt, the original occupant of the Rethmore Home. (Courtesy of Donald Zeiller.)

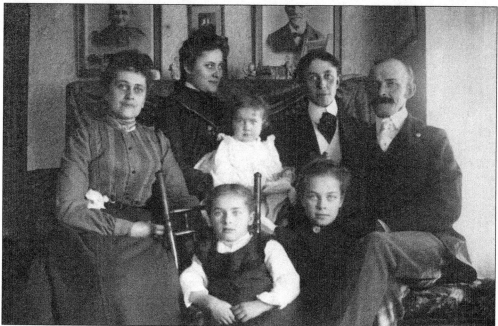

This family portrait shows the Peter J. Westervelt family of Norman Place in 1901. He was the son of Andrew H. Westervelt of the Rethmore Home and advertised carpentry services in the local newspaper. Clockwise from the far left are Jennie, Berdie, Emma (center), Elmer, Peter J., Daisy, and Clara. Andrew H. Westervelt's portrait is on the wall. (Courtesy of Bill Westervelt.)

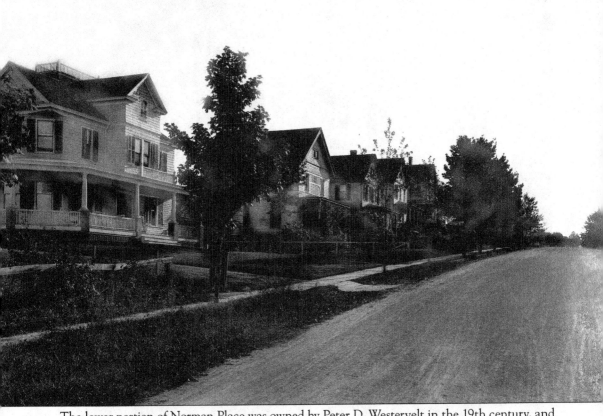

The lower portion of Norman Place was owned by Peter D. Westervelt in the 19th century, and it ran through his property. It was later divided among Westervelt descendants, and members of this family lived here for decades. The upper part was owned by Norman Dodge through the dawn of the 20th century. The street lies one block south of West Clinton Avenue and in later years was populated by some of the community's leading personalities, including Chief Chester (Chet) Campbell of the police department, Fire Chief William Kiessel, John Ostermann of Tenafly Trust Company, assessor Frank Mowerson, councilman Jules Bierhals, and well-known real estate agent Claremont Bodecker. This photograph dates from the first decade of the 20th century. (Courtesy of Bob Fuller.)

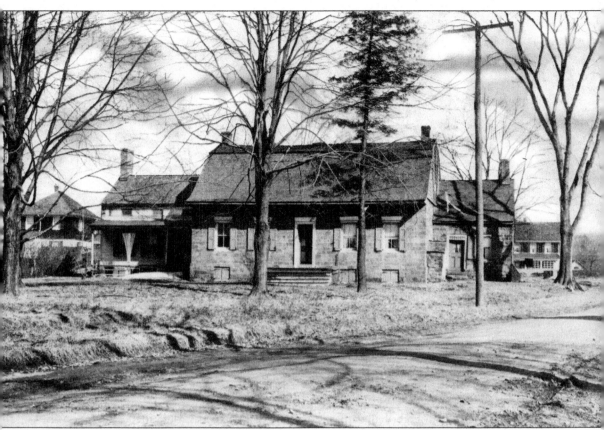

The oldest known of Tenafly's early stone houses is the Roelof Westervelt house. The southern part of the house may have been built about 1745 when Roelof Westervelt was married. The steep pitched roof over the red sandstone contrasts the gambrel roof over the center section, which was built about 1798. The northern frame wing was erected in 1825. Descendants of the Westervelt family owned the property until 1923. Later the property was occupied by the Tenafly Weavers.

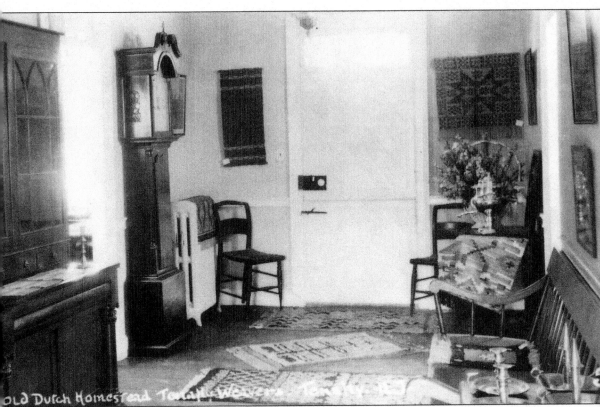

OLD DUTCH HOMESTEAD TENAFLY WEAVERS TENAFLY N.J.

Pictured above is the center hall with its front and rear entrances when the Tenafly Weavers worked in the Westervelt house throughout the 1930s. The looms were set up in the upstairs studio room, which was about 30 by 65 feet with 18-foot ceilings lit by skylights. The Tenafly Weavers gave demonstrations, sold their products, and served tea in the house and on the terrace. During these years, an antique dealer had a shop in the south wing.

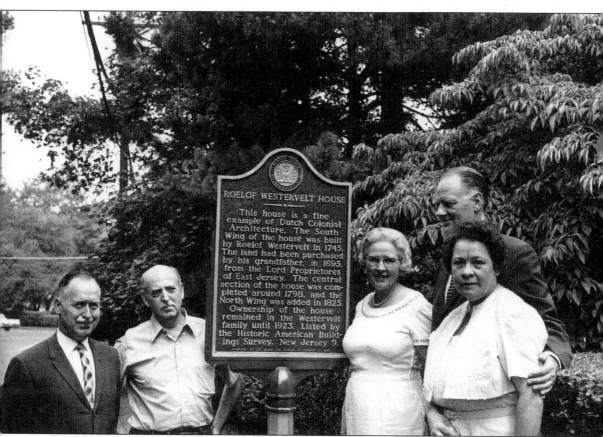

The plaque reads:

ROELOF WESTERVELT HOUSE

This house is a fine example of Dutch Colonial Architecture. The South Wing of the house was built by Roelof Westervelt in 1745. The land had been purchased by his grandfather, in 1695, from the Lord Proprietores of East Jersey. The central section of the house was completed around 1798, and the North Wing was added in 1825. Ownership of the house remained in the Westervelt family until 1923. Listed by the Historic American Buildings Survey. New Jersey 9.

From 1938 until the mid-1990s, George Price owned 81 Westervelt Avenue where he raised his family and did all his work. This famous cartoonist and illustrator celebrated a 65-year career working for the *New Yorker* magazine. Shown at the dedication of the Bergen County Historical Society plaque in 1965 are, from left to right, unidentified; George Price; Virginia Mosley, historian; Mayor Robert Shull; and Florence Price. In the 1980s, the house was placed on the National Register of Historic Places.

By the mid-19th century, a major landowner in Tenafly was George Huyler, whose farm is shown here. He inherited the Huyler homestead on County Road, which was once part of Tenafly (now part of Cresskill). Over the decades, Huyler sold large parcels of land for residential or commercial development. He also contributed one-third of the cost for the Daniel T. Atwood–designed railroad station.

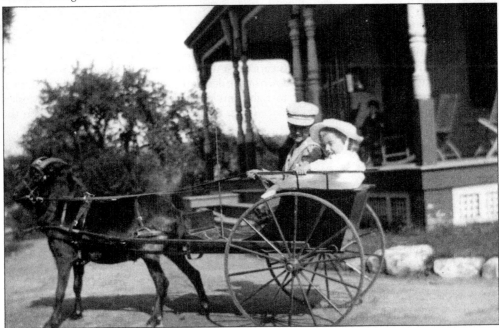

In the late 1800s and early 1900s, farmland was ample enough that many residents had animals on their properties. As seen in this Huyler family photograph from about 1905, the farm animals also provided transportation and entertainment for the younger generation. Stephen Clarke's cow Daisy was important enough that a street in Tenafly was named after it.

Henry Palmer was a public-spirited man who helped to incorporate Tenafly as a borough. He was elected Tenafly's first mayor by a landslide of 237 out of 241 votes cast in 1894. Subsequently, he served three terms. Palmer was president of the old Staten Island Dyeing Establishment of New York City.

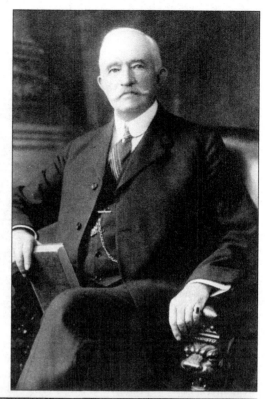

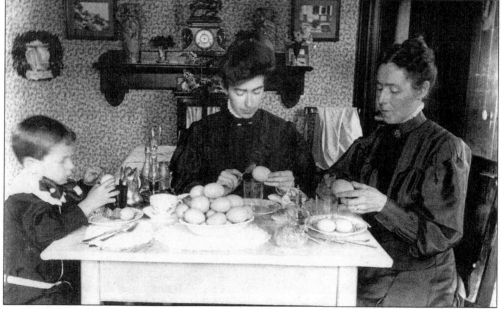

In this photograph from about 1900, a family sits at the dinner table and enjoys an afternoon meal. The eggs at the table were likely from chickens kept by the family on its property. Alternatively, there were several chicken farms in Tenafly in the early part of the 20th century where fresh eggs could be purchased, including the Aurora farm on County Road near Hudson Avenue and the Conniscliffe poultry farm.

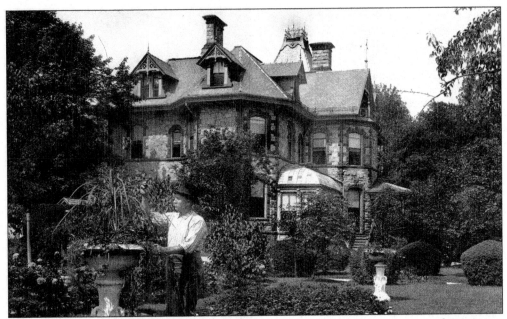

During the late 19th century, the Browning estate was described as a magnificent stone mansion on superb park grounds. The estate belonging to John Hull Browning was 26.5 acres in size, located on Engle Street a block south of East Clinton Avenue. Browning, president of the Northern Railroad as well as Browning-King Clothiers, was very active in Tenafly affairs, including serving as president of the board of education in 1905. (Courtesy of Bob Fuller.)

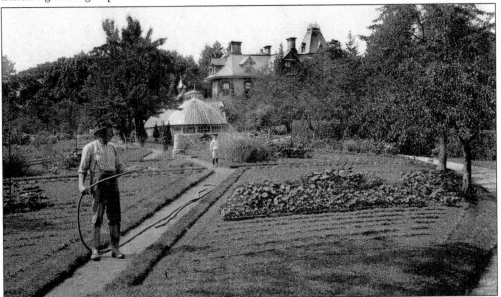

Here is a view of the expansive gardens and grounds behind Browning's home on Engle Street around 1905. Browning, originally from Orange, moved to Tenafly and became president of the Northern Railroad after Charles Sisson retired. Browning served Tenafly in many capacities, including as the president of the board of education, the largest stock subscriber of Tenafly Hall, the treasurer of the Church of the Atonement, and the president of the local publishing company. Browning died in 1914 in the ferry house on his way to New York. (Courtesy of Bob Fuller.)

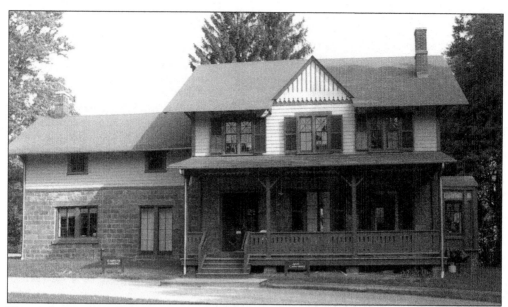

This is the Demarest-Lyle house, which was built in the 1790s. Two generations of the Demarest family lived in it until 1866, when it was purchased by John Samuel Lyle. The Newcomb family occupied the house in the late 1800s, as Lyle's first wife was the former Elizabeth Newcomb. The Lyle family owned property from Knickerbocker Road to Jefferson Avenue bordered by West Clinton Avenue and Riveredge Road. During World War I, after Lyle died, the land was used mostly for victory gardens. Later Charles Reis developed a significant section of it.

Lyle was vice president of the Lord and Taylor store and a busy merchant and philanthropist. His estate was surrounded by a horse track where the family and guests often rode. Happy Land was built on Lyle's property as a fresh-air home. According to the local newspaper, "He helped the poor, elderly and orphaned and founded Happy Land. This house on his estate was a home where working women from the city could go for vacations from the sweatshops."

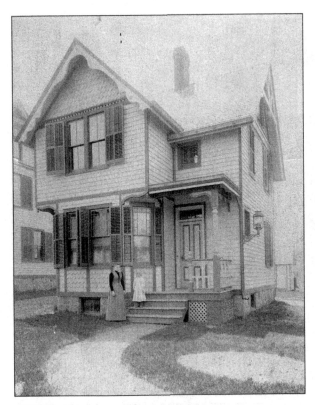

This is the Renner house at 24 Hillside Avenue in around 1900. The house was built before 1890 by Adolph H. Renner, one of Tenafly's pioneer residents. He and his mother purchased the land in the 1880s. In 1898, he was one of the first from this vicinity to volunteer for the Spanish-American War as a corporal. During his time of service, he contracted typhoid fever. (Courtesy of Alice Renner Rigney.)

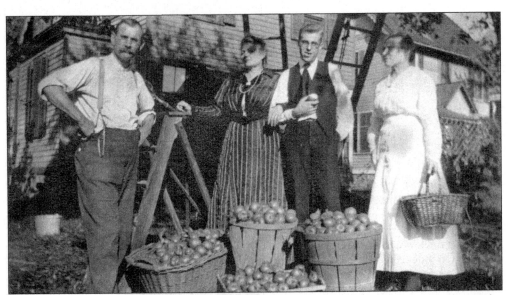

In this late-1920s photograph, members the Renner family of 24 Hillside Avenue display apples they picked from trees grown in their yard. The Renners had three apple trees, two cherry trees, a mulberry tree, and numerous grapevines, which seemed to pop up in yards all over town. Pictured are, from left to right, Adolph H. Renner, two unidentified Renner relatives, and Josephine Renner (Adolph's wife). (Courtesy of Alice Renner Rigney.)

Elmer A. Renner sits upon the stone wall of the Browning estate about 1910. The Browning estate (162 Engle Street) was known as the Allen estate from 1918 to 1941. Rex Whitaker Allen, president of the American Institute of Architects, owned the property until the late 1930s when it was redeveloped into smaller lots and new housing. (Courtesy of Alice Renner Rigney.)

Alice Renner sits on the well that served 24 Hillside Avenue. Most springs in the area were closed and wells were deemed unsafe for drinking by the mid-1920s due to the typhoid epidemic. However, there was a drinkable well across the dirt road behind the Mount Carmel rectory through the 1930s, which was fed by a clean cold spring. In earlier days, there was a famous well in front of Demarest's where people would gather to talk. (Courtesy of Alice Renner Rigney.)

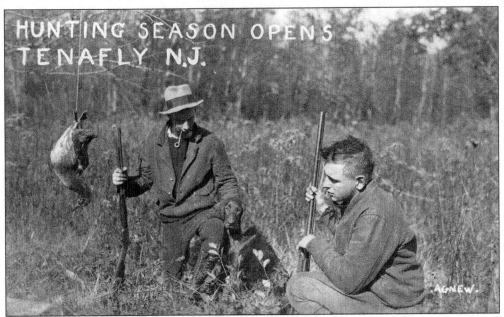

Irving Zeiller and Barney Colvin are seen hunting in the woods of Tenafly in 1930. Today much of the local wildlife has been forced into people's backyards or has strayed elsewhere, as development has grown, and the woods have diminished over the years. (Courtesy of Donald Zeiller.)

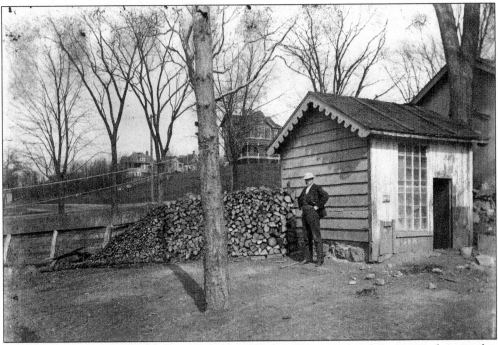

This home owner on Valley Place in the early 1900s has done quite a job cutting and sorting his firewood. Through the trees in the background is a house on East Clinton Avenue, and farther in the distance are a couple of houses on Hillside Avenue. (Courtesy of Bob Fuller.)

Jacob Van Buskirk of 12 Valley Place is outside his home about 1905. Being pulled on a sled by his father was all the entertainment he needed. A professional photographer boarded at this home just after 1900 and captured several views of what life was like at the time. (Courtesy of Bob Fuller.)

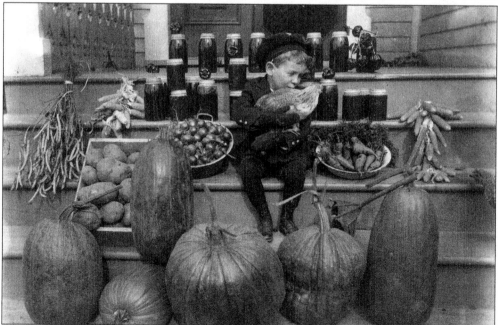

Still on Valley Place, a boy sits on his front steps with fruits from the fall crop. Some residents had chickens, and many more canned their own crops to use during the winter. At one point, a farm east of Valley Place ran up to Engle Street on the south side of Clinton Avenue. (Courtesy of Bob Fuller.)

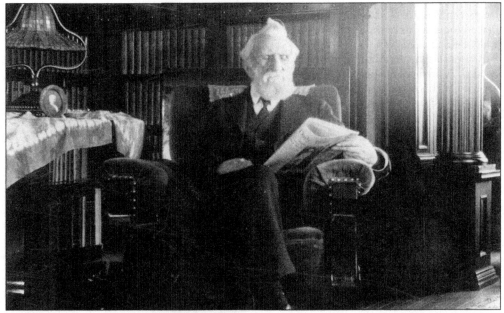

Dr. John J. Haring, found here seated in his home in 1927, was Tenafly's beloved local physician. Descended from the Harings of Holland, he moved his family to town in 1870. Haring was attending physician at Englewood Hospital and was elected president of the Bergen County Medical Society. His writings and reminiscences were printed in the local newspaper and later became a book called *Floating Chips*.

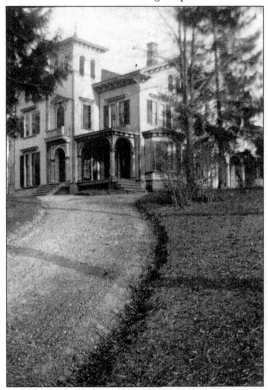

Designed by Daniel T. Atwood, this towered villa-style house was on Magnolia and Hillside Avenues. Its design plans were published in 1876. About 1885, Amelia Haring, the doctor's daughter, established a private school in the house. Later the school was moved to a little frame building on Ravine Road. Around 1950, a new Mary Fisher home building was constructed on the Haring property. The original stone wall still remains along Hillside Avenue.

The house at 56 Magnolia Avenue is now part of the Magnolia Avenue Historic District. It was built in 1917 for former mayor F. L. Colver. From 1926 to the mid-1940s, it was owned by Ralph and Zella Westervelt. The house was designed by Dolhemos and Coffin architects. It featured old-fashioned hand-split Cyprus shingles and a fieldstone chimney, emphasizing its Colonial character. (Courtesy of Charlotte Westervelt Bispham.)

At the first meeting of the Tenafly Woman's Club in 1927, Zella Westervelt was elected its first president. Some of the club's notable contributions are the fountain and cherry trees at the commons, plantings along Dean Drive, and computers for the library. In 2007, the club celebrated 80 years of community service. (Courtesy of Charlotte Westervelt Bispham.)

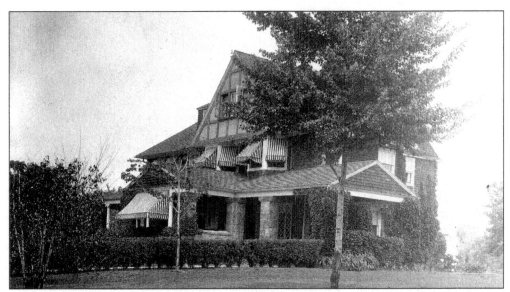

In the early 1920s, the Pendergast family moved to the house at 286 Engle Street, known as Conniscliffe. Its land extended between Engle Street and Grandview Terrace along Highwood Avenue. The old stone wall on Engle Street ran along the property. The family included daughter Virginia, son Norbert II (who later owned the nursery on County Road), and Norbert and Virginia Pendergast Sr. The Vaughan house was built on the site of Norbert Pendergast Sr.'s garden. Later on, the house was torn down and the property divided. (Courtesy of Norbert Pendergast III.)

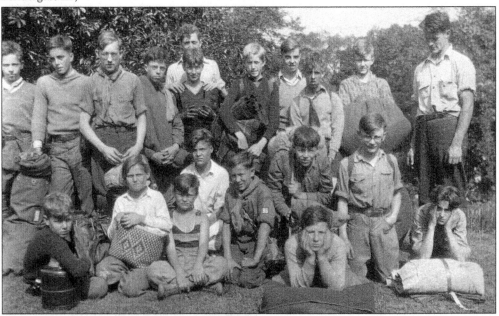

The Boy Scout troop leader, far right, is Norbert Pendergast II. He was the first Eagle Scout in Tenafly. In 1934, his troop, No. 86, went on a holiday weekend camping trip to Camp No-Be-Bo-Sco (North Bergen Boy Scouts) in Blairstown. Also, scoutmaster Herbert Birch's Troop No. 116 went along in one of the two trucks owned by Pendergast. Clinton Fuller went along as the chef. (Courtesy of Lynne Pendergast Ferdon.)

Two

SERVING TOWN AND COUNTRY

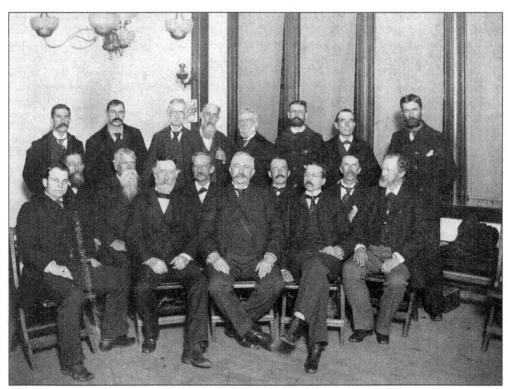

This photograph of early Tenafly borough officials was taken in 1895. Included in this photograph are Mayor Henry Palmer (sixth from the left, first row), the councilmen, the borough clerk, the tax assessor, and other members of the Tenafly administration.

Tenafly Hall was built by private subscription on the corner of Highwood Avenue and Jay Street and opened in 1893. In 1894, the borough rented space in Tenafly Hall since it did not have its own offices. At this time, elected officials kept offices in their houses, where many of the records were kept. On the first floor, there was a Tenafly Society room at the rear of the building while the Tenakill Outing Club room was in the front, and the lodge room took up the remainder of the first floor. There was also retail space facing Highwood Avenue on the first floor. The photograph above is from about 1915. The Tenafly Volunteer Fire Department (below) was organized at a meeting held on July 7, 1891. The first firehouse was built on the southwest corner of West Clinton Avenue and Franklin Street. Alarms were sounded on the iron ring in front, which was made from a segment of railroad track.

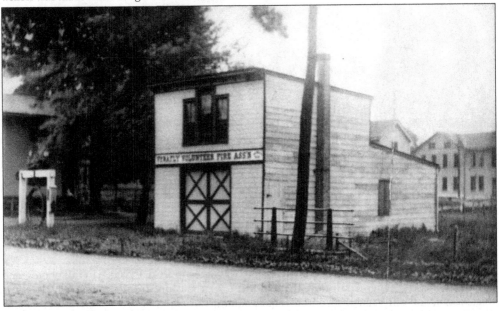

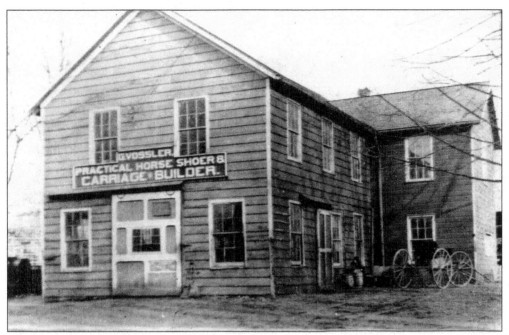

Besides making horseshoes and carriages, blacksmith George Vossler also built the original horse-drawn ladder truck used by the Tenafly Volunteer Fire Department. The truck was stored on West Railroad Avenue until the first firehouse was purchased in 1892. Vossler was located on Tenafly Road.

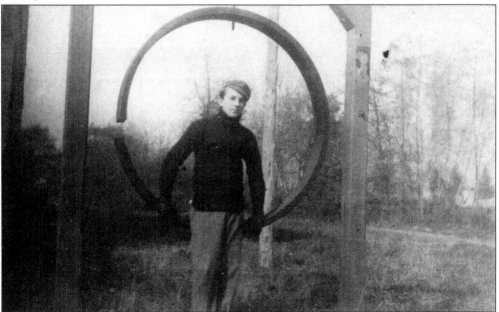

This photograph shows an unidentified young man standing in front of the fire ring outside the original firehouse located on West Clinton Avenue about 1900. There were four other rings located in different sections of town. The fire ring was hit with a small hammer in order to sound the alarm and alert residents and firemen to fires. One of these stands today, as a relic of the past, in front of the firehouse on Riveredge Road.

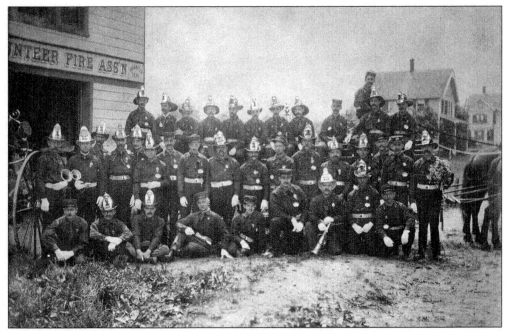

The Tenafly Volunteer Fire Department of 1895 stands in front of the original firehouse on Clinton Avenue near Franklin Street. The horse-drawn pumper is partially hidden from view. In the early days, a fireman would have to run a block to the stable to unhitch a horse team and bring it back to be hooked up to the wagon. (Courtesy of Bob Fuller.)

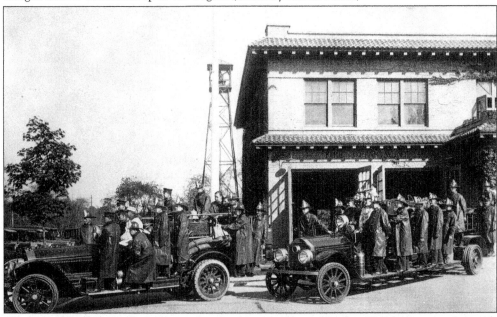

This is a 1932 photograph featuring the fire department outside the 1913 firehouse at borough hall. Some of the famous fires in town include the 1888 rubber factory blaze, the 1907 fire that destroyed the Clinton Hotel, a 1920 fire at David Watson's feed barn, and the Taveniere and Johnson stable fire of December 1924. The first motor-driven fire engine in Tenafly was rolled out in 1921. (Courtesy of Bob Fuller.)

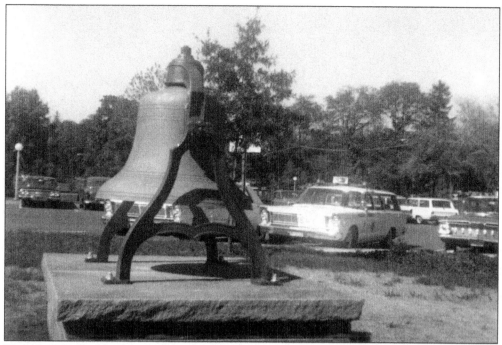

This photograph shows the fire bell standing outside the current borough hall. The bell originally hung in a tower next to the former firehouse on Washington Street. The bell can be seen in the previous photograph.

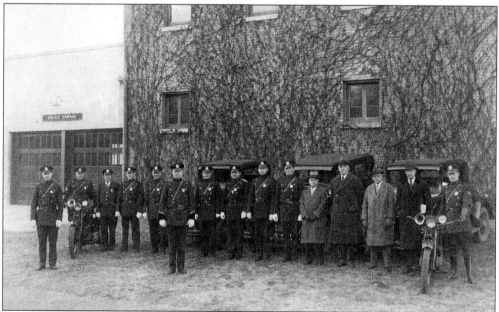

In 1904, the post office was robbed, and in 1908, its safe was cracked. The police blotter was started in 1905. After robberies at the Coppells' and later the Kidders', the mayor and council were convinced to reorganize the police department. In 1909, two bicycles were purchased for the department followed by two police dogs in 1915. In 1917, the department had six riot guns and 12 nightsticks. This photograph is dated 1931.

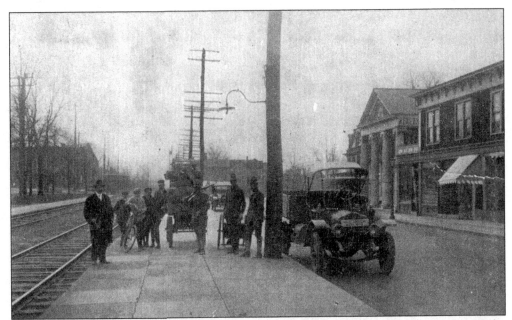

This photograph from about 1918 shows soldiers on Railroad Avenue during World War I. The theater and the Tenafly Trust bank have yet to be built. The militia headquarters for Camp Merritt was at the borough hall on Washington Street. There were two squads of military police helping the Tenafly officers throughout World War I. They were also assisted by the home guard.

Police chief Chester (Chet) Campbell, center, began as a patrolman in Tenafly in 1923. He rose through the ranks very quickly, becoming chief in 1929 at age 30. Campbell remained in that role for 40 years until his retirement in 1969 at age 70.

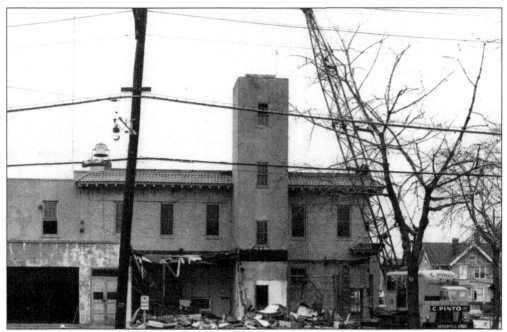

A bronze plaque on today's firehouse tower marks the date of September 27, 1778. That is the date of the first fire on record for the area that became Tenafly. A spy who led the British from Ivy Lane to the Baylor massacre in River Vale returned home to find all his belongings burned in a fire. This photograph shows the tearing down of the borough hall and firehouse in 1963.

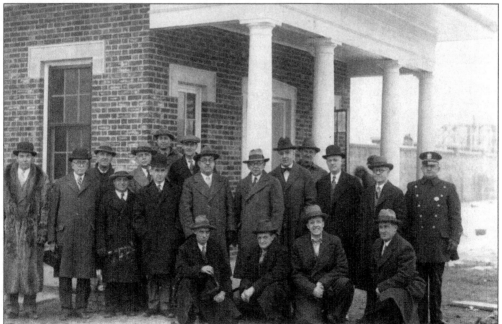

Tenafly officials gather outside the headquarters for the new sewage plant in Tenafly in 1927. The sewer system was an improvement to Tenafly that took several years to pass due to the cost and scope of the project. Once the sewer lines were installed in 1927 and 1928, many of the remaining unpaved roads were macadamized.

33

Camp Merritt was named for Wesley Merritt, a major general in the Union cavalry in the Civil War. The camp was constructed beginning in 1917. It initially housed 20,000 men, eventually quartering 40,000 troops ready for embarkation during World War I. Between 1917 and 1919, over one million soldiers passed through the camp, which covered 770 acres in Bergenfield, Cresskill, Dumont, and Tenafly.

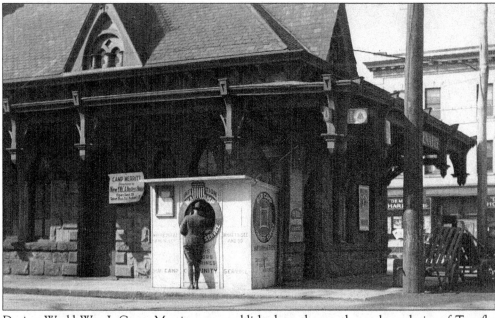

During World War I, Camp Merritt was established on the northwest boundaries of Tenafly. Tenafly organizations were actively trying to cope with the more than half a million men who left Camp Merritt for overseas and even more men returning for duty through this camp. The camp was so large that 11,000 two-pound loaves of bread were baked daily. Note Demarest's hardware store on Railroad Avenue behind the railroad station.

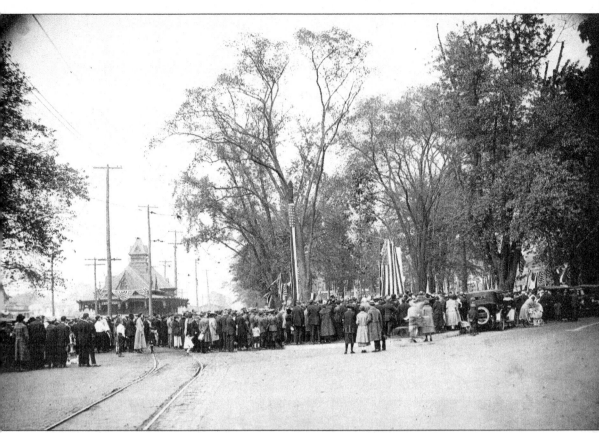

A large crowd gathers in Huyler Park for the dedication of the war memorial on October 12, 1923. The monument is behind the flag, waiting to be unveiled. The railroad station and the grandstand are decorated in patriotic bunting. The mayor of Tenafly at this time was Charles C. Walden Jr. Malcolm S. Mackay was chairman of the Tenafly War Memorial Committee.

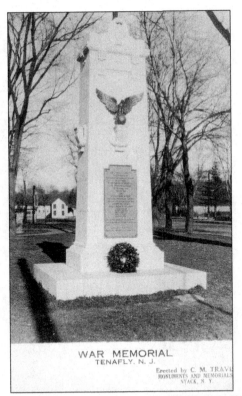

WAR MEMORIAL
TENAFLY, N. J.

Erected by C. M. TRAVI
MONUMENTS AND MEMORIALS
NYACK, N. Y.

In 1923, an ordinance was passed, for "the construction of a public memorial to commemorate the services to their country of the residents of Tenafly during the world war." This memorial was to be constructed at the southern end of Huyler Park. The sum of $7,000 was appropriated for this memorial. On February 9, 1923, the resolution passed with all councilmen in favor and none against.

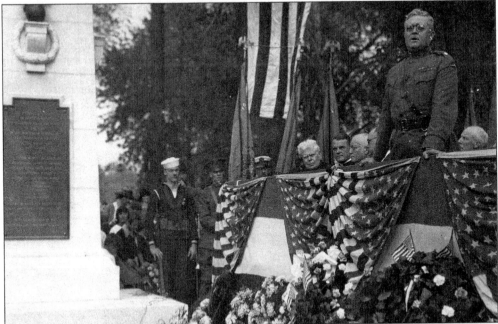

The monument displays the names of all the Tenafly men who served in World War I. It also names on its honor roll those who died in World War II, including Glenn Miller. In all, 5 men died in World War I, 27 died in World War II, and 5 died in the Korean War. Their memories are preserved on this monument.

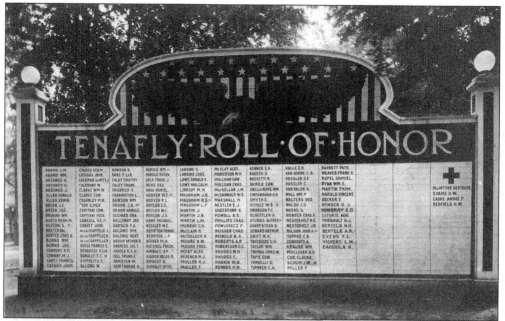

This roll of honor placard was dedicated to the Tenafly men who served in World War I. A celebration in their honor took place at Knickerbocker Country Club on October 1, 1919. Mayor Stanley Clarke delivered a rousing speech. Later residents gathered in Huyler Park, and a fireworks display rounded out the evening's festivities.

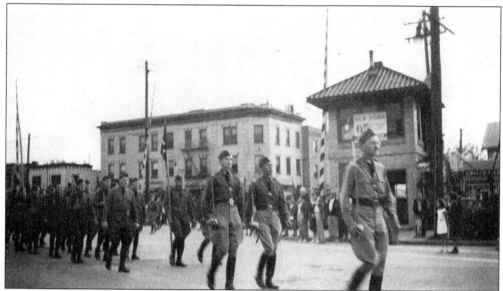

A parade has always taken place in Tenafly on Memorial Day, formerly known as Decoration Day. In years gone by, the parade route went through the downtown, up Highwood Avenue, and along County Road before heading to Huyler Park. That route has since been abbreviated, although Huyler Park remains the final destination of the Memorial Day parade today. The veterans pictured are marching in their World War I uniforms. (Courtesy of John McNamara.)

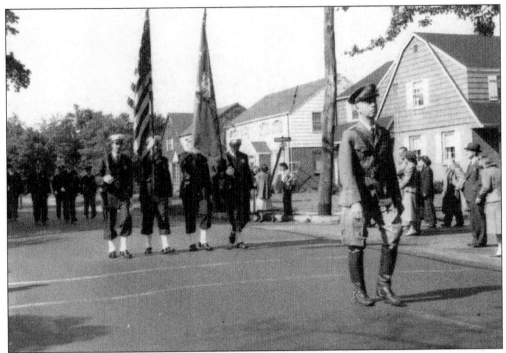

LeRoy Demarest, a decorated World War I major and owner of Demarest's retail store, led the annual Memorial Day parade from the 1920s into the 1950s. Here Demarest leads the procession north on Tenafly Road past Norman Place. This photograph was taken in 1949.

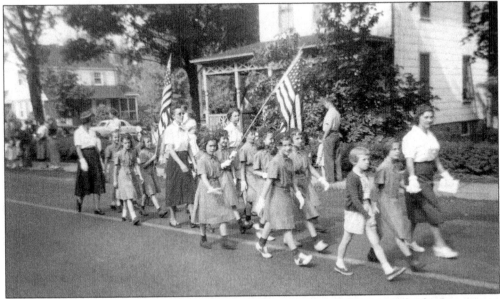

Girl Scout Troop No. 1 of Tenafly began in June 1920 with Elizabeth Hoag as its leader. It grew over the years, contributing community service and camping. In the early years, it camped at Green Pond and finally at Camp Ten-Engle in the Bear Mountain Reservation. Here is a contingent of Girl Scouts marching in the Memorial Day parade of 1953. (Courtesy of Donald Zeiller.)

Three

SCHOOL DAYS

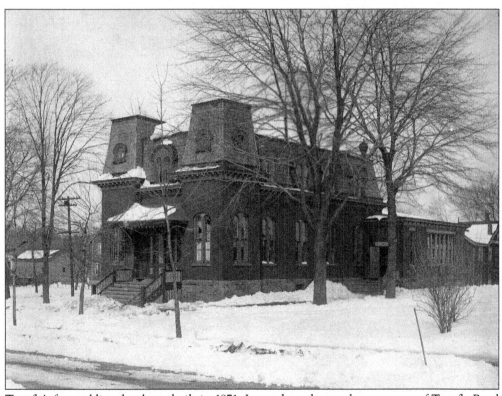

Tenafly's first public school was built in 1871. It stood on the northeast corner of Tenafly Road and West Clinton Avenue. This magnificent redbrick building had one room on each floor. There were two teachers and 40 to 50 pupils. By 1900, there were five teachers in the grammar school, and it was crowded even with the Rethmore Home serving as a kindergarten.

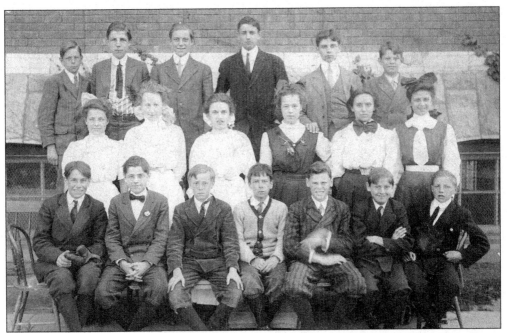

The Browning School eighth-grade class photograph also features some seventh graders. Seven names in this eighth-grade class were well-known names in Tenafly: George Carroll, Frank Garsch, William Rankin, William Snellgrove, Anita Proses, Helen Harper, and Elmer Renner. The photograph is dated June 29, 1910, and the diplomas given to these youngsters were presented by John Hull Browning. (Courtesy of Alice Renner Rigney.)

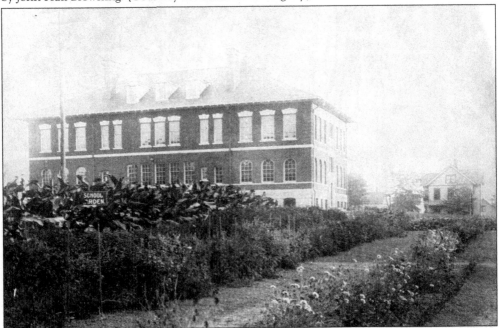

Shown here in this 1910 photograph is a view of the Browning School from the back. Students were encouraged to maintain their own gardens behind the school. The house visible in the background across Clinton Avenue still stands today.

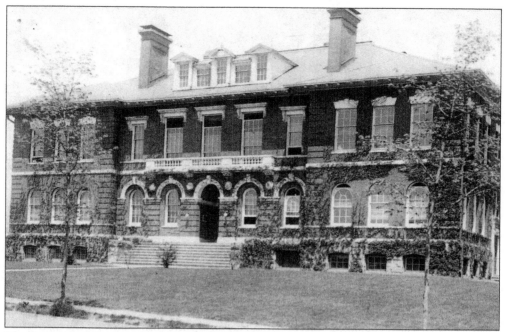

The Browning School was designed by Tenafly architect William Stoddart. It is the best example of Second Renaissance Revival style in town. The first graduates of the Browning School were from the class of 1908. Ralph S. Maugham was in charge of the school system for 45 years. Gertrude Stites, who married Clifford Demarest, taught for 38 years.

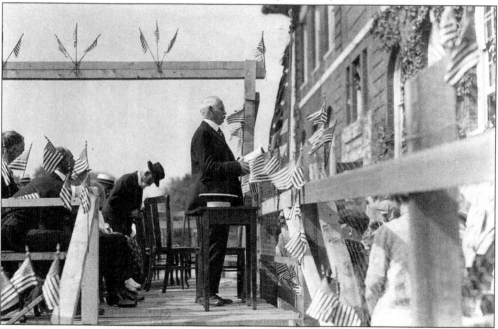

Maugham addresses the students during the cornerstone-laying ceremony of the high school in 1921. Maugham was the sole survivor when a Hudson River outing turned tragic. Five of six passengers drowned, including Maugham's four-year-old son, when a boat on which they were traveling capsized on the eastern shore.

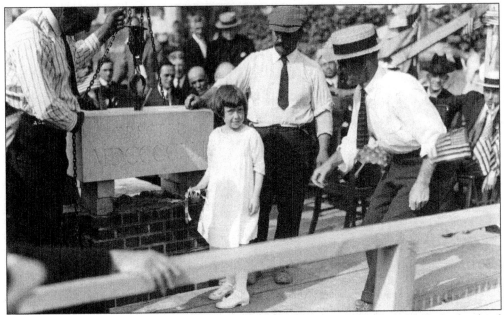

Gladys Huyler, daughter of former mayor Byron Huyler, lays the cornerstone for the high school on West Clinton Avenue and Tenafly Road in 1921. Speeches were made and flags were waved amid the pomp of the occasion. The new school meant that for the first time Tenafly students would attend high school in their own town. Prior to having their own high school in Tenafly, students attended high school in Englewood.

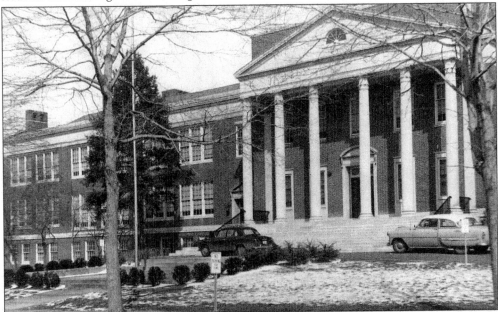

Tenafly's first high school at Tenafly Road and West Clinton Avenue was designed by architects Sibley, Licht and Hacker, who also designed Fort Lee and Dwight Morrow (Englewood) High Schools. It was built as an addition to the west side of the Browning School, yet the middle and high schools remained formally separated for many years. After standing vacant for several years, the building reopened as the Browning House condominiums in 1982.

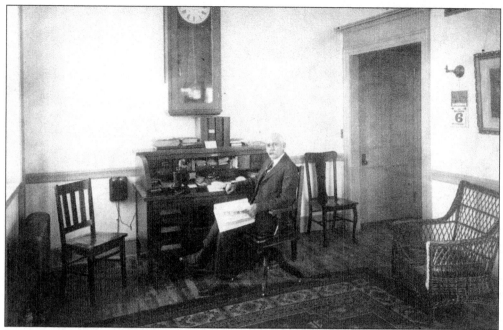

Ralph S. Maugham, longtime superintendent of the Tenafly school system, is pictured sitting in his office during the 1920s. Before retiring in 1931, Maugham saw an elementary school named after him. He lived at the Maugham homestead at 23 Hillside Avenue and brought up several children there, one of who also became a teacher. He died in 1932.

Maugham arrived in Tenafly in 1886. His dedication to enriching his community through service included being a teacher, a principal, the superintendent of schools, an organist, and a choirmaster. The Maugham elementary school, built in 1929 and located on Magnolia Avenue, was named to honor him. This photograph is a back view dating from the 1930s. (Courtesy of Tom Swift.)

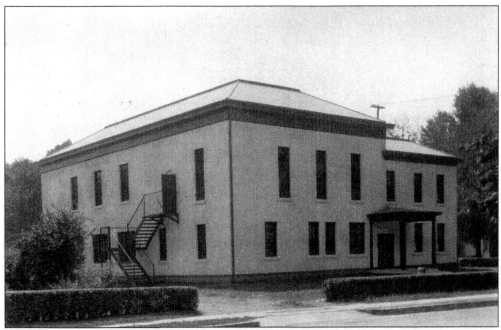

Mount Carmel Catholic School began in a building located at 195 County Road in 1879. In 1908, the edifice above, formerly the Richter shade factory, was purchased and rebuilt to become a school. This building was used for decades until a new one was ready in the same complex for the 1952–1953 school year.

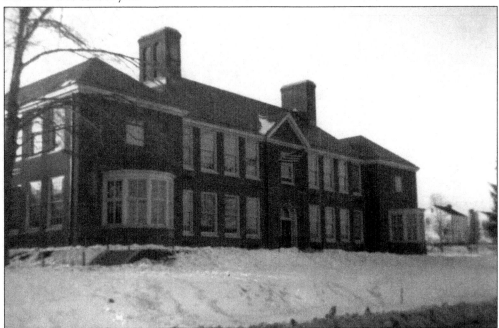

After the elementary school capacity in Tenafly had reached its maximum in the 1930s, a site was chosen for a second freestanding facility on Jefferson Avenue across from Roosevelt Common. Malcolm S. Mackay School, named after the Tenafly civic leader who donated Roosevelt Common to the town, opened in the fall of 1940. The first enrollment was 325 students.

Four

PARKS AND RECREATION

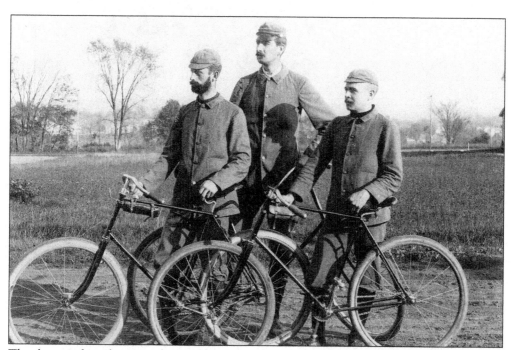

The three cyclists shown in this 1890s photograph are members of the Century Bicycle Club of the Northern Valley. There was nothing like a leisurely bicycle ride through the countryside on a nice summer day. Cyclists continue to pass through Tenafly's scenic streets today.

This portrait of Alliene Sherman Davis Johnson (1882–1960) was taken in the living room of 137 Engle Street around 1915 prior to her marriage. In the 1920s, the grounds of her house had a prize-winning iris collection, many of which she hybridized herself. She willed her estate to the borough to be used as a park and garden for all to enjoy. The house was demolished, but its stone foundations were retained to form a sunken garden for azaleas and rhododendrons. Dedication ceremonies for Davis-Johnson Park were held in June 1975.

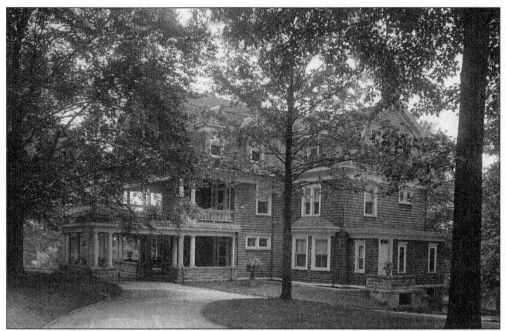

The Davis-Johnson house stood at the northwest corner of Engle Street and Westervelt Avenue (137 Engle Street). Also known as the Chestnuts, it is now part of Davis-Johnson Park. The house was built in the early 1860s and demolished in the 1970s per the specifications of the donation that all buildings be demolished. It was purchased by George W. Davis, a member of the New York Stock Exchange, in 1891. He was a banker, a broker, and a sportsman. Davis's daughter Alliene Sherman Davis Johnson owned the house from 1936 until her death. Pictured below in a 1930s photograph is the maintenance house of the Johnson estate. The house and this stable had been remodeled in the 1870s. The head gardener for the estate was James Cassidy, who lived over the stables until 1939.

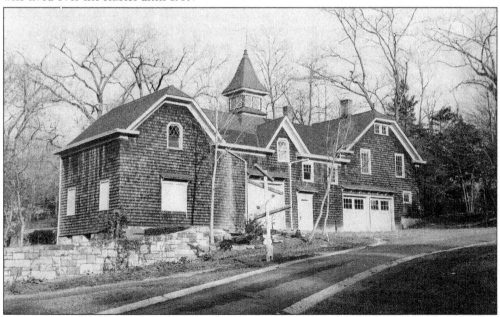

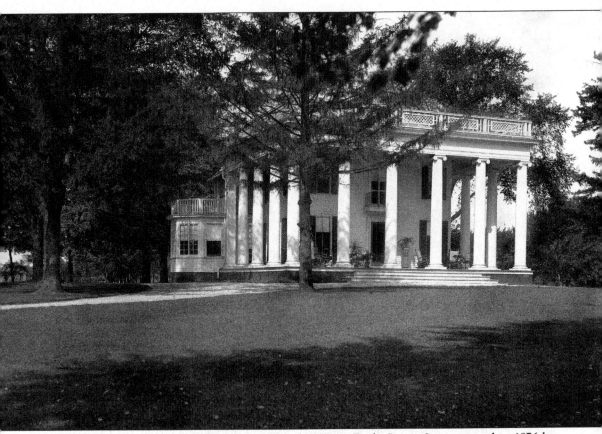

The Noyes house was built between 1867 and 1876 on Engle Street. It was owned in 1876 by William King, a commuter-resident who worked in New York City. Banker Weller Noyes owned the house during the early decades of the 1900s. This photograph was taken around 1905, prior to the subsequent renovation. In October 1931, the residence was broken into and robbed while Noyes was asleep in the room where the robbery occurred. The thieves were very proficient, as even the Noyeses' dog was not disturbed. Four thousand dollars in jewelry was taken. The house was demolished in the 1990s, and the land is now part of Davis-Johnson Park. The Noyes family also owned a home on Knickerbocker Road just over the Cresskill border. (Courtesy of Bob Fuller.)

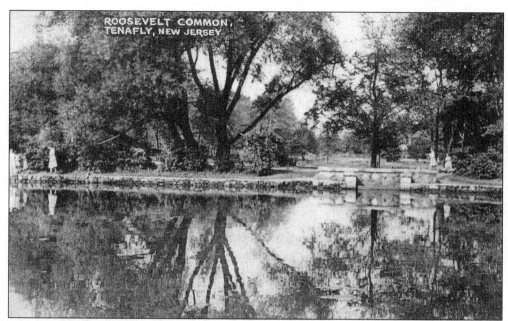

In 1924, Malcolm S. Mackay and his sister Jenny presented Tenafly with the 31-acre commons, proposed to include a track, athletic field, and area for classes in forestry, agriculture, and gardening. It was also intended as a resting place for the public, a theater area for outdoor dramatics, and a skating pond (above). The ballpark area was originally called Eager Field, named after a former Tenafly mayor. The monument (below) sculpted by Norwegian Tryqve Hammer (1878–1947) was dedicated to the memory of Theodore Roosevelt during a ceremony held on July 15, 1928. (Above, courtesy of Paul J. Stefanowicz.)

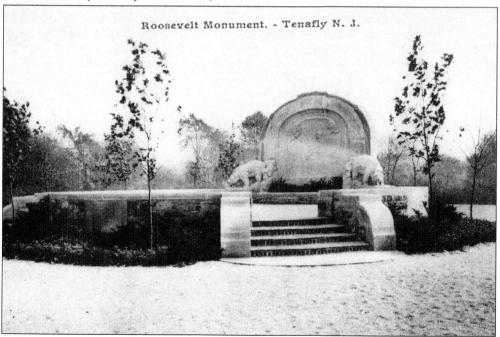

Roosevelt Monument. - Tenafly N. J.

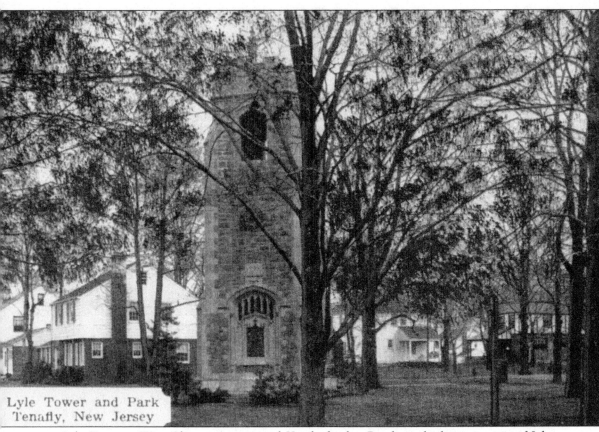

Lyle Tower and Park
Tenafly, New Jersey

Lyle Tower at West Clinton Avenue and Knickerbocker Road was built in memory of John
Samuel Lyle, philanthropist and benefactor, by his second wife, Julia Lyle. In 1936, Charles
Reis purchased 30 acres of the Lyle estate on which to build 100 houses. Julia Lyle kept the
100-by-100-foot lot with the tower as tribute to her husband. His memory was also honored when
Reis named the development Lylewood Hills.

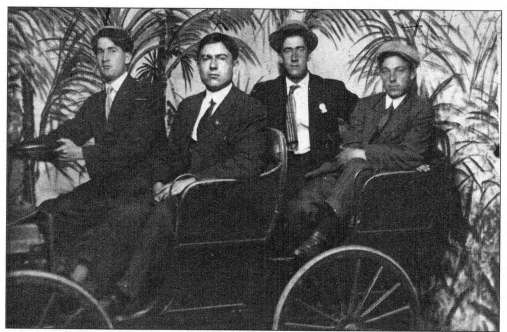

Four young men from Tenafly are seen here posing at a Coney Island photographer's studio about 1915, recording the day's outing. Beginning after the Civil War, Coney Island became a popular place to enjoy the beach and amusements for the day. From left to right are John Harold, Eugene Valle, William Foxen, and Paul McKeon.

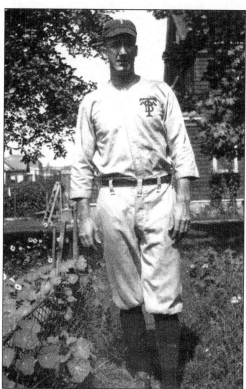

William Foxen (1879–1937) was a local baseball legend. In addition to several successful years on the Tenafly team, Foxen spent three seasons with the Philadelphia Phillies and two more with the Chicago Cubs as a pitcher. He was also a member of the Tenafly Volunteer Fire Department.

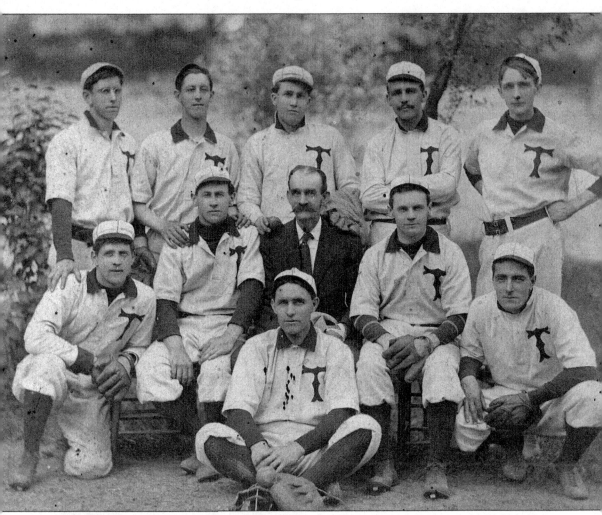

The Tenafly baseball team was considered semiprofessional in that the pitcher and perhaps another key player received small portions of money collected at the gate. This team from about 1909 features several faces familiar to old-time Tenafly. Second from right in the back row is longtime borough clerk N. M. F. "Doc" Dennis. To the right of Dennis is George Huyler, brother of former Tenafly mayor Byron Huyler. George Huyler lived at 45 Magnolia Avenue. The manager, center of middle row, is Chris Coyte, son of renowned local shop owner George Coyte.

Members of the Van Buskirk family sit on their lawn on Valley Place, watching the Tenafly baseball club play on the ball field that was found near the corner of East Clinton Avenue and Front Street (now Dean Drive). Note the hand-built flagpole to the left. James Butler's land agency developed the area around the ball field, which eventually became the site of Hough's Funeral Home. Edgar Hough purchased the funeral service operation from John Westervelt in the early 1900s after serving as his partner. Hough's Funeral Home then became Pell's and is now the current location of Barrett's Funeral Home.

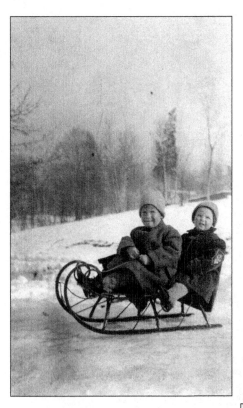

The Redfields of Engle Street were descendants of Dumont Clarke, the banker after whom the borough of Dumont was named. Alice Clarke Redfield, a daughter of his, stood barely four feet tall and wore a child's size 12 shoe; her husband, architect Henry Redfield, was over six feet tall. In this photograph, brothers Clarke, left, (1907–1972) and John Redfield (1909–1984) are sledding down a hill near their home in 1912. The Redfield family lived in Tenafly into the 1980s.

One of the popular uses of Demarest's horse-pulled sleigh was pulling neighborhood children on rides in the snow on Hillside Avenue and the vicinity. Even after businesses had moved away from horses and sleighs for the most part, the tradition of winter sleigh rides continued into the 1930s. (Courtesy of Tom Swift.)

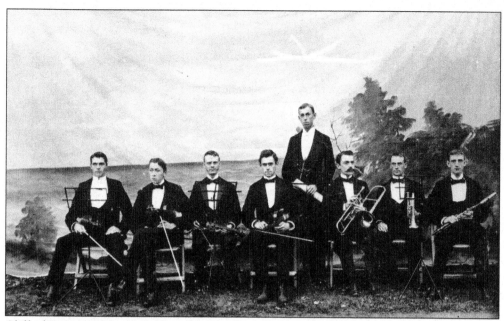

Clifford Demarest, shown leading the Tenafly Orchestra in 1939, had a friendship with famous orchestra leader Walter Damrosch. On a wager between the two gentlemen, Demarest presented George Frideric Handel's *Messiah* at a concert of local high school groups. Damrosch himself was in the audience and rose to a standing ovation for the performance. The piece is still performed at Tenafly High School. Demarest acquired his musical skills from his mother.

Ruth Wilcox, shown in 1933, came from an artist family, as both her mother and father were well-known artists. In April 1933, her parents, Ruth Turner Wilcox and Ray Wilcox, arranged an art exhibit sponsored by the Tenafly Woman's Club. It was a three-day memorable exhibit featuring Tenafly artists and sculptors. Some of the artists were Ray Wilcox, Ruth Turner Wilcox, Harvey Dunn, Ella Condie Lamb, Annie E. Grannis, and Ralph Fuller.

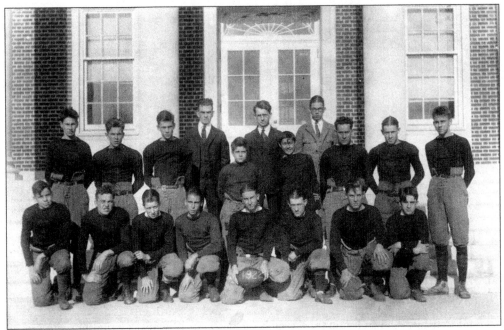

Shown is the 1922 football team of Tenafly High School. Since the school opened in 1922, this is known to be the first varsity football squad. First known as the Orange and Blacks, the Tenafly Tiger became the football team's official mascot, undoubtedly adapted from the Princeton Tiger.

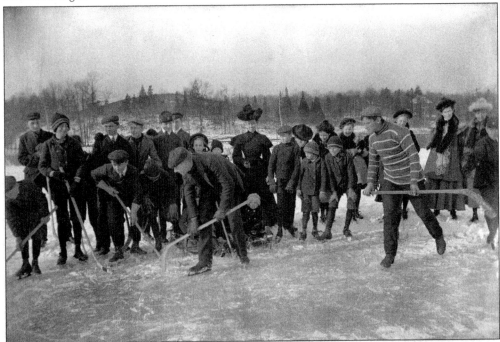

A group of young hockey players skate in an open area of the Huyler property about 1900. The lake on which they are skating no longer exists. The railroad tracks along Front Street (now Dean Drive) are slightly visible in the background to the west. (Courtesy of Bob Fuller.)

56

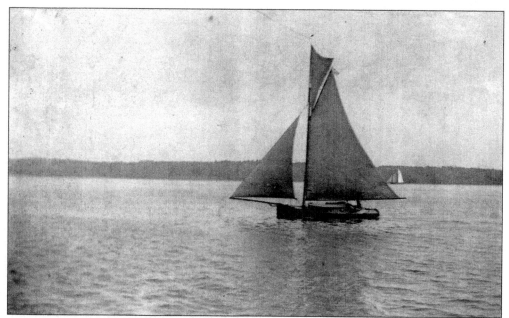

Charles Everett and his family came to Tenafly in 1867. From 1876 to 1890, the Everetts wrote down their experiences in town in a diary for later generations to enjoy. The Everett homestead, located on Forest Road, later belonged to artist Harvey Dunn and is on the town historic register. This photograph of Everett's yacht dates to 1890. The Everetts sailed their yacht on the Hudson River.

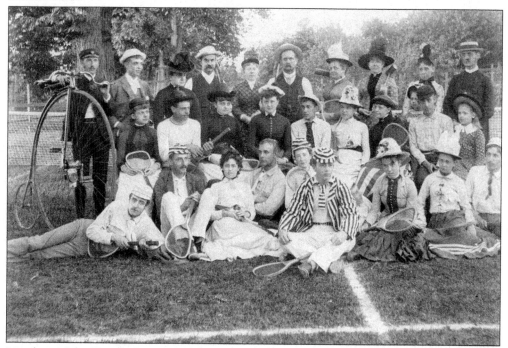

Members of the Tenafly Country Club, later known as the Tenafly Tennis Club, pose on a court in 1885. The country club reorganized as the tennis club in 1920 and still exists today at its original location on Glenwood Road just north of Highwood Avenue.

Knickerbocker Country Club, shown in 1930, was incorporated in 1914 by a group of leading local citizens. Prominent among these people was Malcolm S. Mackay, who is considered to be the club's founder. He donated much of the land and the clubhouse. The property on the east side, formerly owned by the DeMott family, was the site of an early stone quarry in the area. The stone from this quarry was used to build the First Presbyterian Church in Englewood.

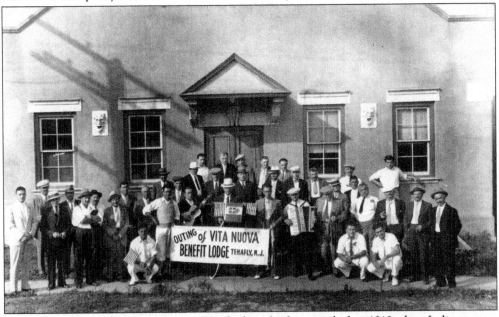

The Italian American community in Tenafly dates back to just before 1910 when Italians came with their families to picnic in town by way of the trolley. They soon began building homes in the vicinity of the northern part of County Road. In this 1934 photograph, the members of the Italian American Club pose in front of their building, the Vita Nuova (later Club 50) located on Prospect Terrace. The club is still active today, with over 60 members.

Five

CHURCHES

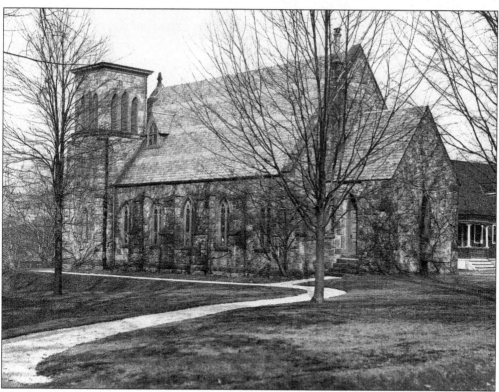

The Presbyterian Church at Tenafly was the first parish formally organized in the community in November 1865. In the early days of Tenafly, one door in the church was always left open so that the church bell could be rung for an alarm in case of a fire in town. The church is part of the Magnolia Avenue Historic District. This view dates back to the 1920s. (Courtesy of the Presbyterian Church at Tenafly.)

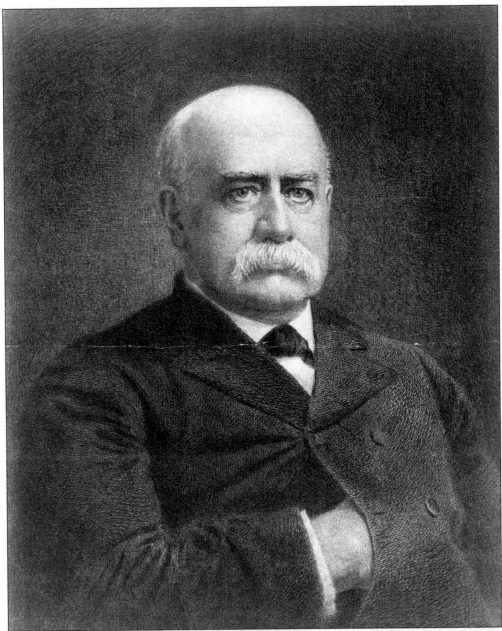

Judge Ashbel Green (1825–1898) was a prominent attorney in New York and a cofounder of the New York Bar Association. He was the grandson of Rev. Ashbel Green, a former president of Princeton University. Green's large estate on the east side of Engle Street was north of Oak Street. His original home was destroyed by fire in 1880, but he rebuilt it. The Green property, known as Sunninghill Farm, stayed in his daughters' families—the Thatchers and the Evans—through the 1920s. Green's wife, Louisa, was a major contributor to the early Presbyterian Church in town. Green built the stone manse across from the church to honor his wife in memoriam. (Courtesy of the Presbyterian Church at Tenafly.)

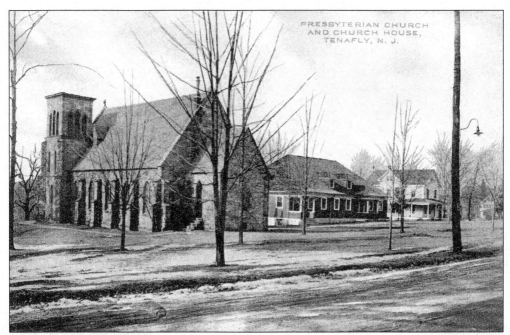

Shown in the photograph above are the original Presbyterian church and the Sunday school church house located in the center. At the northwest end of the church house was a stone quarry that was partially filled in to create a parking lot. The white house on the right is where the new church was built. Below is the scene showing the cornerstone-laying ceremony for the new Presbyterian church in 1950. (Below, courtesy of the Presbyterian Church at Tenafly.)

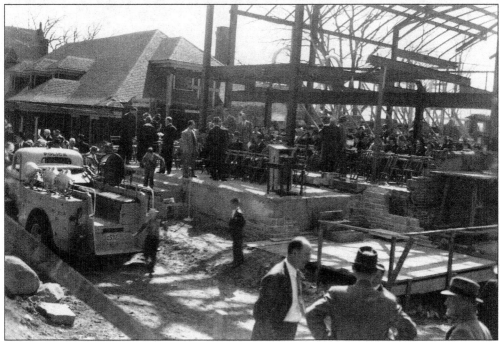

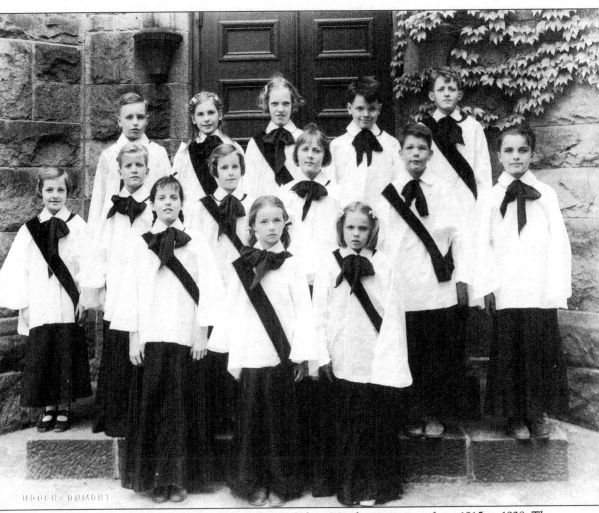

The junior choir was organized when Rev. J. Calvin Mead was minister from 1915 to 1928. The choir, composed of girls and boys ranging in age from 7 to 14, participated in every Sunday morning service. It assisted the Advent choir and sang a selection of its own, occasionally showcasing a soloist. By 1928, Mrs. F. C. Bangs was choir director. Rev. George Lockwood was pastor from 1928 to 1944. (Courtesy of the Presbyterian Church at Tenafly.)

The Tenafly Library, right, stood for many years next to Washington Hall, which hosted various programs and musical acts. The hall became the Grace Chapel and was moved a block to the southwest. Henry Wadham was a founder of the chapel and its leader for over 50 years. When a new Grace Chapel was built in 1955, the former building was named in honor of Wadham and his wife, the former Katherine Redfield.

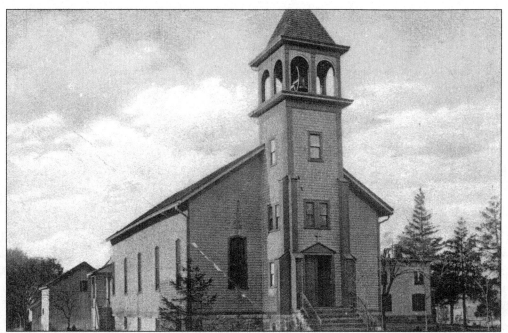

Mount Carmel Roman Catholic Church was founded in 1873 and located on the former Faley Reservation on County Road near Prospect Terrace. In 1905, it was physically moved to Hillside Avenue and New Street, a dirt road connecting Hillside and East Clinton Avenues. In 1952, a new church was built next to this one, facing County Road, and the original building was demolished.

The Mahanswere descendants of the Jay family, early landowners in Tenafly. Adm. Alfred T. Mahan kept lots on the east hill of Tenafly well past the original sale of the Jay property. The Mahans donated the land where the Church of the Atonement was built and had a street in town named in their honor.

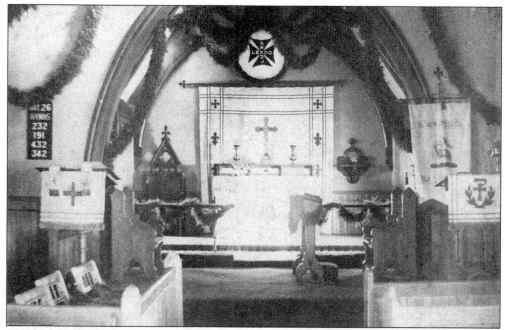

This is the altar and interior of the Church of the Atonement during the winter of 1885. The church's first Bible and prayer books were donated by Mahan while his wife, Mary Helena Mahan, and her sister Jane Swift donated altar vessels. Note the hymns lined up for the next service, done much the same as in modern times.

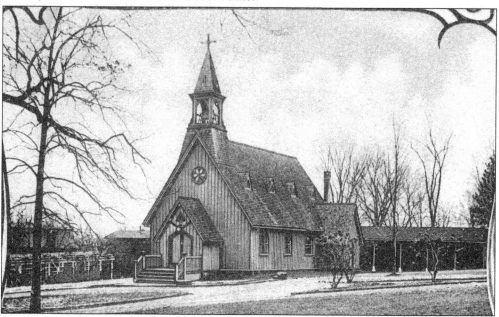

The Tenafly Church of the Atonement was started in 1868 by Rev. Dr. Thomas Richey. He started a boys' school called the Parish of the Atonement Academy at the same time. The land for the church was donated by the Dennis Mahan family of West Point. The first church went up on the donated land at the corner of Engle Street and Highwood Avenue in 1869 at a cost of $3,400. This photograph dates to 1905.

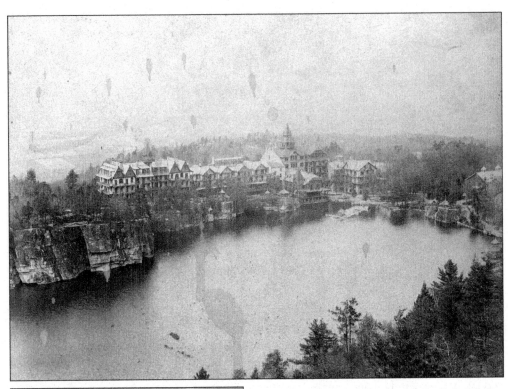

G.M.G. Trip to
Mohonk Castle June 24 & 25. 1892
Ssture Browning
Eva B. Browning
Alice M. Gardiner
Anna Cole
Alex B. Roberts
Grace H. H. Atwood
Eva Westervelt
Jennie Evelyn Berry
Gustava Unkart
Lizzie Phillips
Winifred Priscilla Bowel
Cuthe Nina Atwood
Nellie N. Yoght
Mary Unkart
Maurice Phillips
Albert M. Johnston

Mrs. John Hull Browning organized the Girl's Missionary Guild in the late 1880s. The guild sponsored fairs and entertainment to raise money for missions to 13 states as well as China and Africa. This group of girls from the church Sunday school class also enjoyed outings to many well-known places like West Point and Rockland Lake. In June 1892, their party of 12 enjoyed a four-day weekend at the Mohonk Mountain House in New Paltz, New York. They all signed the back of this photograph.

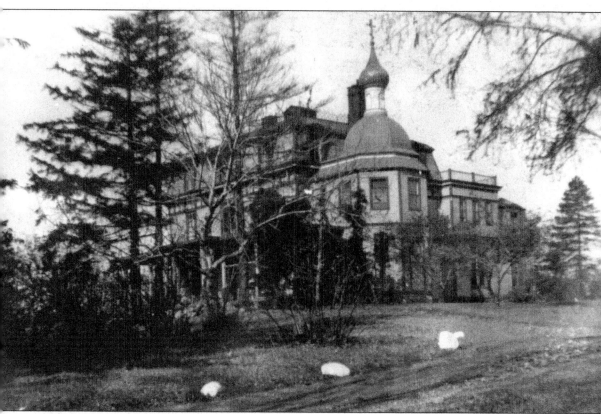

This is a photograph from about 1920 of St. Platon's Russian Orthodox Seminary. The school moved from Minnesota in 1912 and was located on Knickerbocker Road on 45 acres (10 of which were in Tenafly, the rest in Bergenfield). The seminary housed 78 students. Two horses and a sled were sent to the seminary from Russia by Czar Nicholas II in 1912. Once the Russian Revolution was underway and funding to the seminary was cut off, seminarians farmed their own fruits and vegetables on the property. The seminary closed in 1923, and the Tenafly acreage is now the location of the Franciscan Sisters. (Courtesy of Sasha Ressetar.)

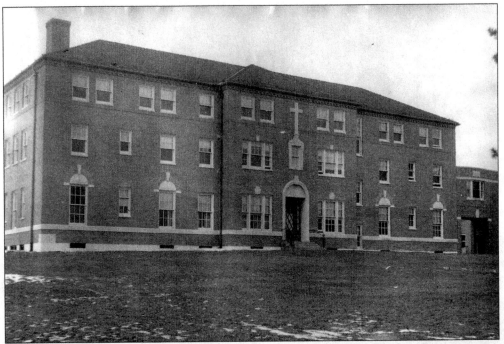

Pictured is the Franciscan convent, the first building on the former Russian seminary property after it was taken over by the Franciscan Sisters. Later a chapel was built next to the convent. A gift shop is currently located on the complex as well.

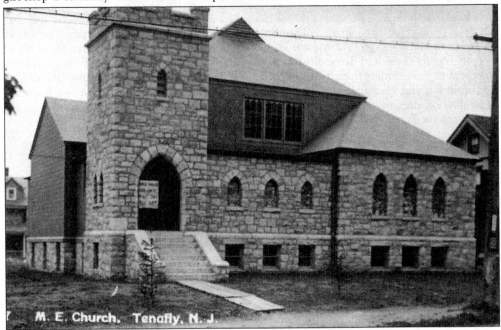

In 1908, the earliest services of the Tenafly Methodist Church were held in the Rethmore Home on Tenafly Road. The church on West Clinton Avenue was built within a few years of the church's organization. This Norman Gothic structure was expanded after World War II. In 1959, a memorial fund resulted in the purchase of several Lamb Studio stained-glass windows.

This is the Rethmore Home, formerly at 313 Tenafly Road, which was opened in 1892. This building was originally the home of Andrew H. Westervelt, and in the early 1900s, many still referred to the house as the old Westervelt place. John Hull Browning, a great civic leader, purchased the home and created a facility for the underprivileged. For several years, the Tenafly school system held kindergarten classes in the southern wing.

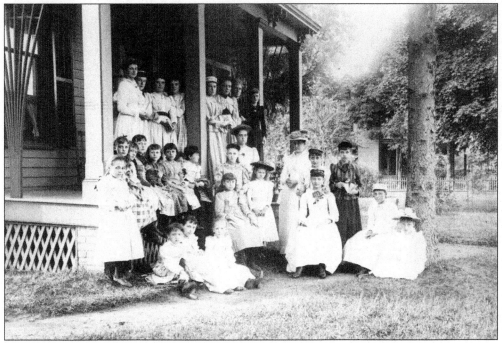

This is the very first class of the Rethmore Home in 1892. The all-women class stayed at the home and took various courses, including sewing instruction. Later the home focused more on providing a fresh-air getaway for underprivileged children from the city.

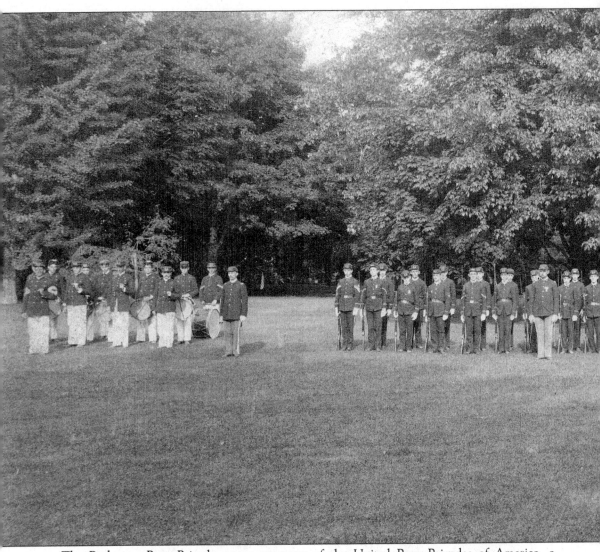

The Rethmore Boys Brigade was a company of the United Boys Brigades of America, a quasi-military group that practiced military formations. It was formed in 1895 and made up of about 50 boys from the Sunday school that was begun by John Hull Browning at the Rethmore Home. Drills were held once a week outside Rethmore; at one time, the barn behind the home was known as the drill hall. After Alex Roberts resigned as major, Adolph H. Renner took over

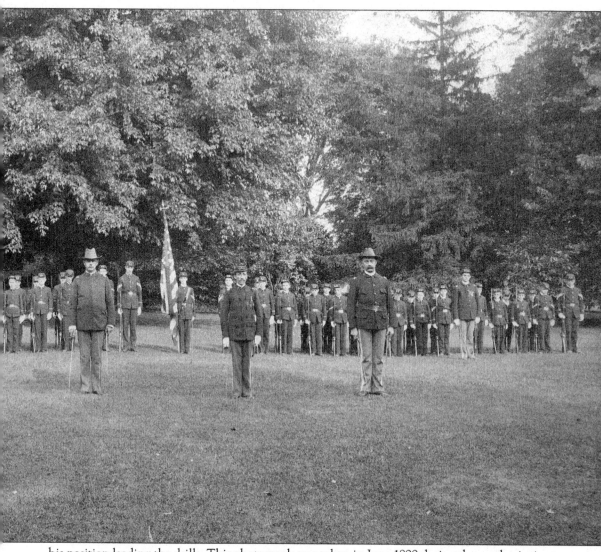

his position leading the drills. This photograph was taken in June 1899 during the yearly picnic and demonstration of military formations at the Browning estate. The band on the left was most likely an Englewood group. In 1902, the Rethmore religious services merged with the Church of the Atonement, and the brigade was eventually disbanded. (Courtesy of Alice Renner Rigney.)

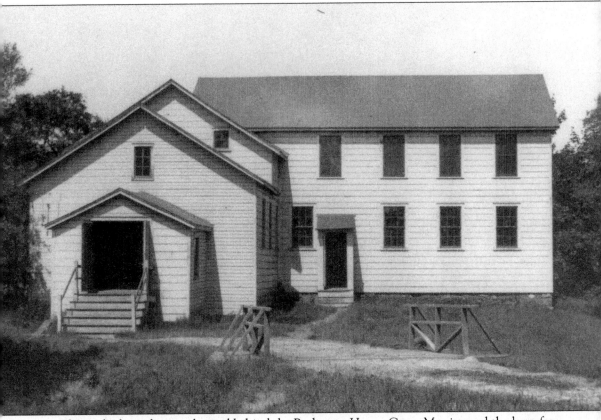

This is the barn that was located behind the Rethmore Home. Camp Merritt used the barn for a community center during World War I, and some of the staff lived here. It was filled with cots. In the mid-1940s, students of Tenafly High School used the barn to house the Tiger's Den, a recreational facility, but neighbors quickly had the idea squashed.

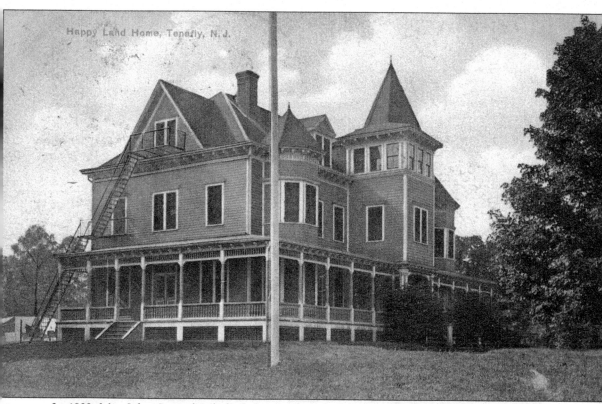

Happy Land Home, Tenafly, N. J.

In 1893, Mrs. John Samuel Lyle had this mansion built to house a fresh-air home, known as Happy Land. During summers, hundreds of children in groups of 40 to 50 came out from the city to stay at this home. It was located on the Lyle property off West Clinton Avenue in the vicinity of today's Surrey Lane. The building was demolished in the early 1930s.

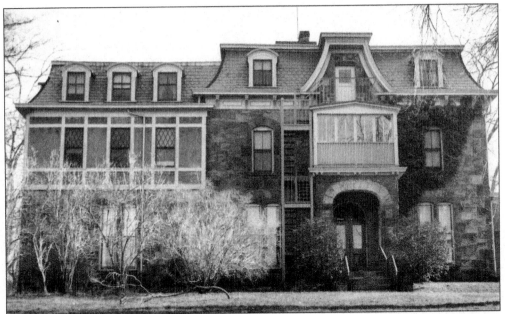

In 1899, the Mary Fisher Retirement Home for Professional Women stood on Riveredge Road, known then as Jay Street. In 1923, it moved into this former mansion of Robert J. Waddell on Engle Street at Forest Road. In the 1950s, a new brick building was constructed for the home at the corner of Magnolia Avenue and Hillside Avenue, the site of Dr. John J. Haring's house. Mary Fisher lived in Tenafly from 1914 to 1920.

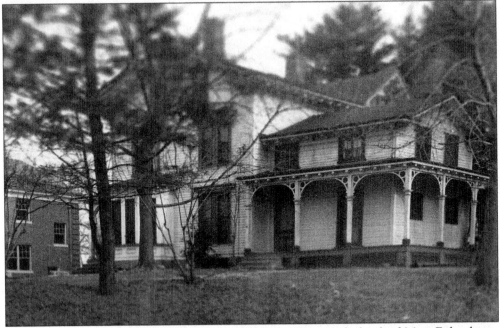

This photograph from about 1950 shows the old Haring house with the third Mary Fisher home in the background. Haring's house had become a private school and later passed into private hands. The Haring house was demolished soon after this photograph was taken, and the Mary Fisher home was also later torn down. Newer residential homes stand in their place.

Six

HOUSES

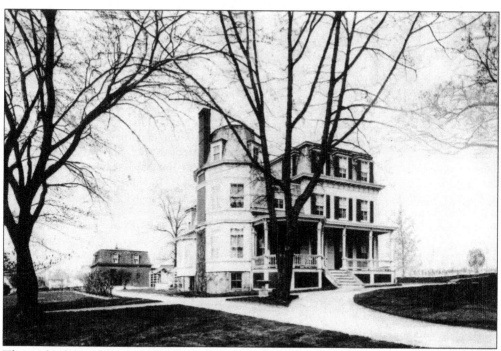

This is the former house of Charles G. Sisson, built about 1868. The family also owned a house next door. The Sissons had a burial vault around the corner just north of the Church of the Atonement. When the church built an addition in 1916, the vault and bodies were moved to Brookside Cemetery. During World War II, the house became the local headquarters for the Red Cross.

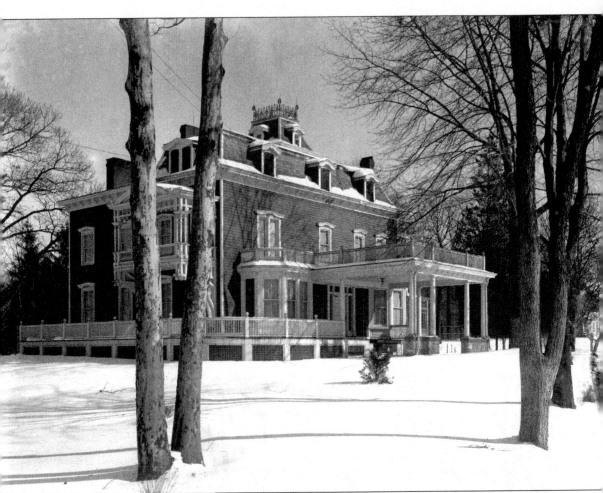

Elizabeth Cady Stanton was a suffragette who drafted what eventually became the 19th Amendment to the Constitution, which gave women the right to vote. She owned this Second Empire–style house at Highwood Avenue and Park Street in Tenafly. The house was built after the Civil War. It was here that the first three volumes of the *History of Woman Suffrage* were written by Susan B. Anthony, Matilda Joslyn Gage, and Stanton. The house was designated as a national historic landmark due to the fact that Stanton lived in it for almost 20 years. This unique view dates to approximately 1903. (Courtesy of Bob Fuller.)

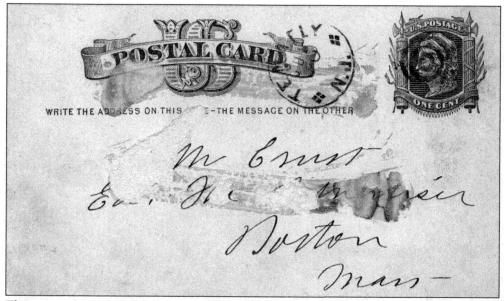

This piece of correspondence from the University of North Carolina–Greensboro collection, written by Anthony while staying with Stanton in Tenafly in June 1881, reads as follows: "Dear Sir—Did you receive the copy of our history sent you by Fowler & Millis?—I hope so—and that you will put it in hands of a receiver who sympathizes with our W.S. Movement—& charge upon her a careful & conscientious review of the contents of the book—not of the present status of our cause—I say "her" because almost no man can read or decide, as if he were one of the disenfranchised class,—man's position to woman today is that of the master to the slave, under the old regime. —Susan B. Anthony." (Courtesy of the University of North Carolina–Greensboro collection.)

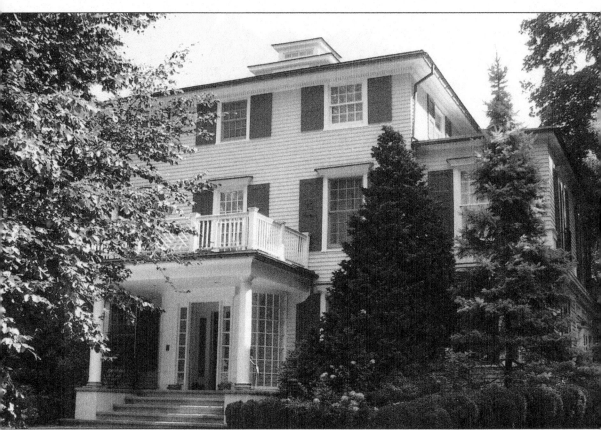

This Park Street house stands as a northern neighbor to the Elizabeth Cady Stanton house. It was built in 1830 by German baroness Esenwein. By the 1870s, after the baroness died, her daughter Harriet lived there alone, and at that time, the house was considered one of Tenafly's most beautiful homes. After some years, the house fell into disrepair and was thought to be haunted, and Harriet was believed to be a witch. After Harriet died in 1923, a family called the Hoeckers moved in and restored the house, adding utilities, side porches, and a vestibule. It became a multifamily home—sort of a boardinghouse—and was sold again in 1948. Once again, the house fell into disrepair until 1958 when it was restored, and the front property was sold off.

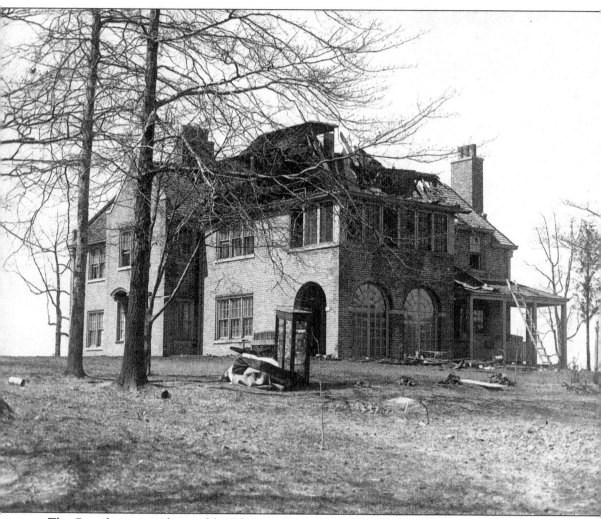

The Cutts house was designed by Edgarton Swartout in 1916. He also designed the Stamford Public Library in Connecticut. About 1919, a fire broke out, and the chemical apparatus from Camp Merritt helped to save the house since the water pressure was not sufficient to reach the roof. According to Elizabeth Cutts, recorded in March 1977, "The men of the Tenafly Fire Volunteer Department were wonderful. They carried the dining room China cabinet, full of China and glass, out on the side lawn and never broke a thing. I can still remember seeing the big black horses galloping along Grandview Terrace pulling the fire engine. I think it was after that fire that the high-pressure water tower was installed at Alpine."

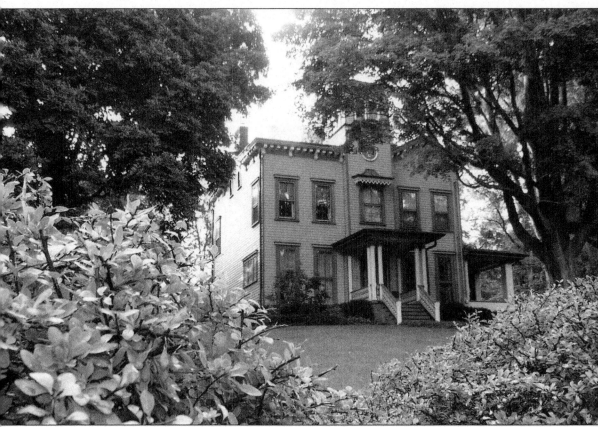

George B. Jellison, seller of "fancy goods and hoop skirts," and his wife, Sarah, lived in Brooklyn for many years before coming to Tenafly in the late 1860s. The Jellison house was designed by famous architect Gamaliel King (the only house in Bergen County definitively attributed to King) and built in 1873. The Italianate-style house has a low hipped roof in the main section and a central tower. The Jellison family most likely lived in the house until George B. Jellison's death in 1891. Harvey and Katherine Wadham owned the house from 1910 until 1962. The Jellison house was a winner of the Bergen County Historic Preservation Commendation Award in 2007 for preservation work done by current owners Karen and Michael Neus. (Courtesy of Paul J. Stefanowicz.)

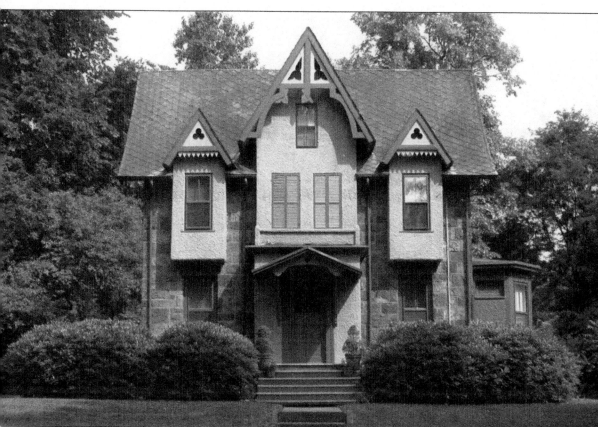

Part of Atwood's Highwood Park Historic District, the Pond House was originally built by architect Daniel T. Atwood as his own home. Early in 1870, Benjamin Franklin Pond settled in this Serpentine Road home and owned a rubber factory in town. This prominent man in Tenafly's early history, after whom Franklin Street was named, had an adventurous career. He was a successful businessman and ship's captain who ran a vessel between the San Francisco and Australian gold rushes. In 1855, his ship struck a reef and sank about 400 miles west of Tahiti. After two months, Pond and some crewmen managed to build a small boat that carried them to Bora-Bora. He then returned to rescue the remaining survivors. He died in 1895 and is buried in Brookside Cemetery in Englewood. He was active in borough affairs, as was his son Henry Pond.

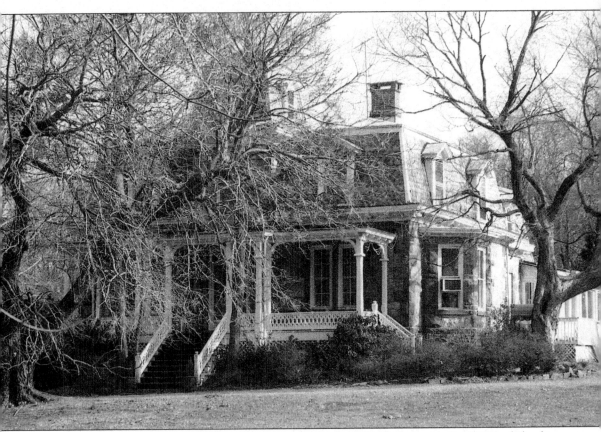

The Laimbeer house on Hudson Avenue near Route 9W was built in the 1860s while the property was owned by William Laimbeer, a commissioner of docks in New York City. Known in the 1800s as Hilltop, the house remains a well-preserved example of mid-19th-century Second Empire style. In 1917, Col. Cunliffe Hall Murray moved to Hilltop with his two daughters. Murray was the shortest man to ever graduate from West Point, at five feet three inches. After graduation, he entered the Indian Wars, where in 1877 he had a command and became known as one of the best Native American fighters over the next 10 years. Murray's funeral services were held in the Church of the Atonement, and he is buried in Arlington National Cemetery outside Washington, D.C. The caretaker cottage has since become the home of the director of the Tenafly Nature Center. (Courtesy of Paul J. Stefanowicz.)

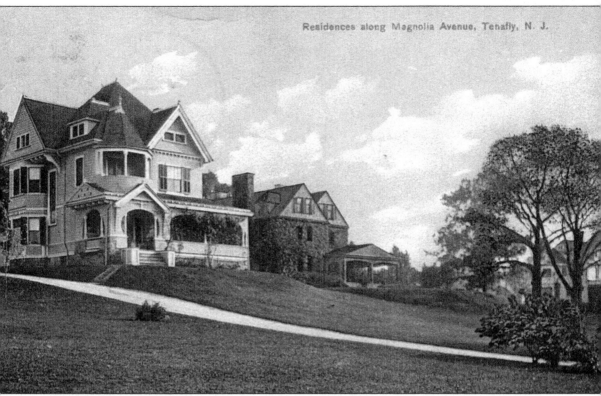

Residences along Magnolia Avenue, Tenafly, N. J.

The Colver house, left, at 54 Magnolia Avenue was the home of Frederic L. Colver (1863–1927), who came to Tenafly from Brooklyn in 1888. He was a well-known publisher of popular magazines. Active in local civic affairs, he served as mayor of Tenafly from 1912 to 1913. He served on the first Tenafly Council in 1894. Colver's daughter-in-law Alice Ross Colver, a prolific author, completed her first book shortly after graduating from Wellesley College, and it was promptly accepted and published. The Presbyterian manse at 50 Magnolia Avenue, right, was constructed in 1890. Judge Ashbel Green gave the building in his late wife's honor. It is a 16-room house built of solid red sandstone. Ministers of the Presbyterian Church at Tenafly resided here from 1890 to 1952 when the church sold it and built a new house. This house is privately owned today.

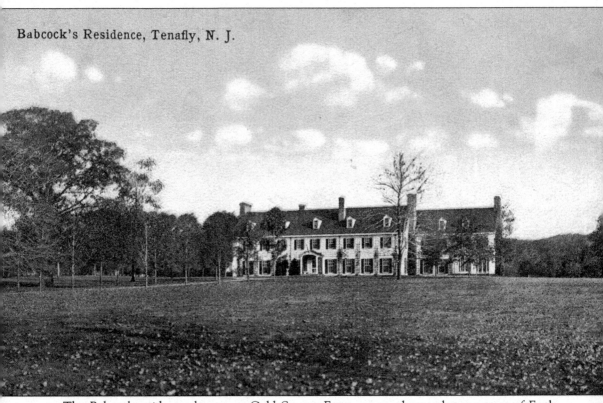

Babcock's Residence, Tenafly, N. J.

The Babcock residence, known as Cold Stream Farm, sat on the northeast corner of Engle and Oak Streets surrounded by a white picket fence. The straight front drive, lined with trees, remains today as Downey Drive. In 1913, Mrs. Graham E. Babcock, sister of Mrs. Herbert Coppell, married William Downey of Brockville, Canada, in this house.

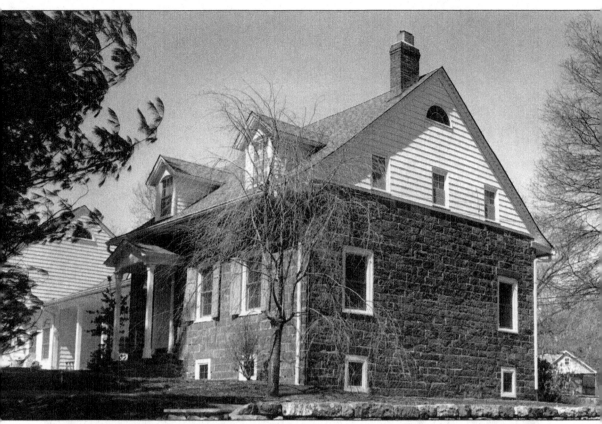

The Christie-Parsels house, above, is on the Tenafly historic register. William Christie purchased 100 acres in Tenafly in 1791. The original wing of this house was built in 1804. Samuel Parsels added the part closest to Jefferson Avenue in 1836. The house is made of red sandstone. Later occupants of the house were the Cole and Newcomb families.

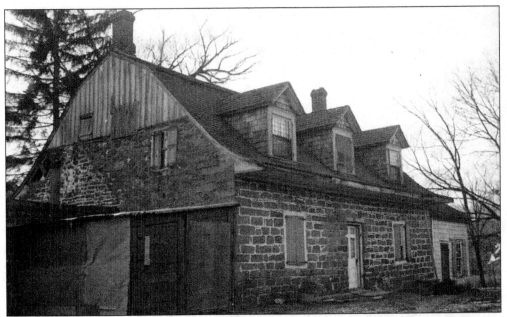

This early stone house originally stood on Sickeltown Road in Pearl River, New York. To save it from demolition, Montgomery Melbourne moved it to a site on Knoll Road in Tenafly around 1938. The house is built mostly of rough-cut sandstone, and the gambrel roof over the main house has a very deep overhang. The dormers and frame wing were not part of the original house in the 1700s. (Courtesy of the Library of Congress.)

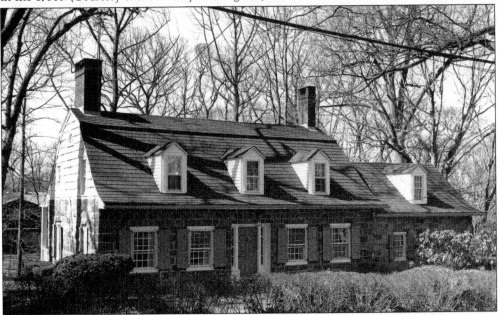

It took two years to rebuild the Sickels house on Knoll Road. Works Progress Administration workers helped with the stonework. Where migrant berry pickers had burned the original doors for firewood, new doors were constructed. The house was designated as one of Tenafly's historic sites in 1995 and is listed on the Historic American Building Survey, which archives house plans and photographs in the Library of Congress.

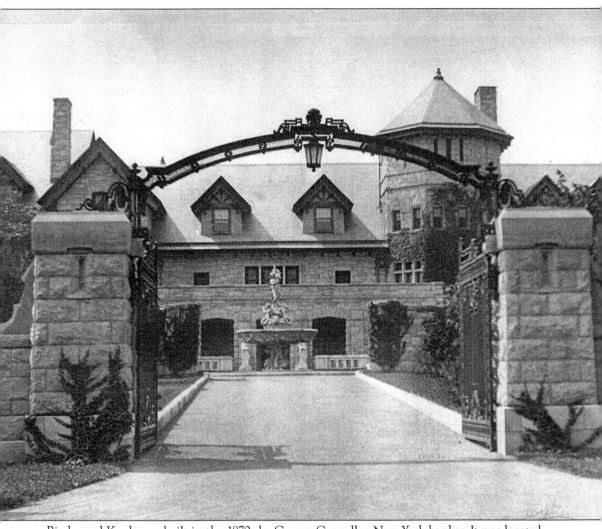

Birchwood Knole was built in the 1870s by George Coppell, a New York banker. It was located on 50 acres on the west side of Engle Street south of Westervelt Avenue. Coppell was born in England and met his wife while living in New Orleans as British consul to that city. In the 1880s, after Coppell acquired the Towers a block to the north, he left Birchwood Knole to his son Herbert. In 1911, Herbert Coppell expanded Birchwood Knole by 200 feet in width to a staggering 68 rooms. The view through the entrance gates shows a large ornate statue, which sat in a circular pool. Behind the house, a second statue was on display. In the early 1920s, the Herbert Coppell family had Birchwood Knole demolished and replaced it farther east on the same property with the house called Cotswold. (Courtesy of John McNamara.)

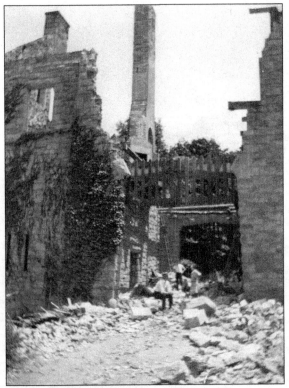

In the early 1920s, Herbert Coppell had Birchwood Knole demolished and had Cotswold built on the same property but closer to Engle Street. Some say that he wanted to move his home away from the noise of the railroad and trolley on Dean Drive; others claim that Mrs. Coppell did not care for the size and appearance of Birchwood Knole. Thus, the 68-room manor was torn down. (Courtesy of John McNamara.)

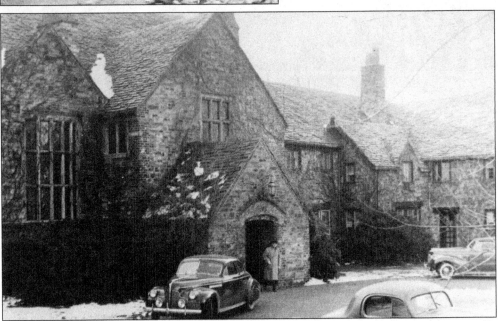

Cotswold is a Tudor Revival house, completed in 1925. In 1935, a few years after Herbert Coppell's death, the house was converted to a multifamily dwelling, as it remains today. Bandleader Glenn Miller and his family had an apartment in Cotswold from 1938 to 1945. When not traveling, it was common to find Miller playing touch football with neighborhood boys on the grounds of the mansion.

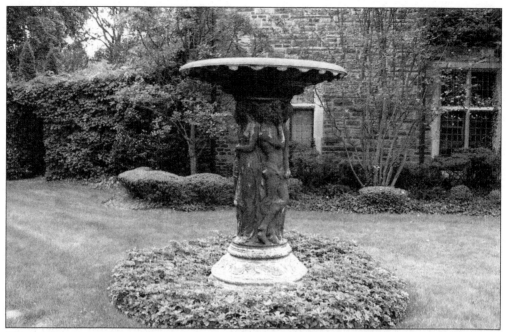

This work was made by early-20th-century sculptor Enid Yanell in 1911 and originally was a working fountain. It sat behind Birchwood Knole and later in front of Cotswold at the center of Herbert Coppell's fishpond. Although the fountain no longer functions, this work still proudly stands outside Cotswold. (Courtesy of Alice Renner Rigney.)

It was a common sight on Engle Street to see the tallyho wagon of the Coppells taking the family to the Church of the Atonement or into Englewood to the theater. The tallyho came complete with a footman, who blew a brass horn to announce its presence. Here Leo Faley tugs a milk can across Coppell grounds in his wagon in the 1920s. The Coppells had their own milk cows on the property. (Courtesy of John McNamara.)

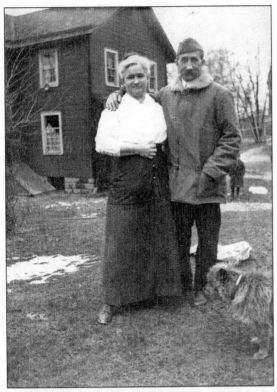

The Coppell family employed dozens of servants, many of whom lived in houses on the Coppell properties. These included maids, butlers, gardeners, laundresses, and drivers. Those people under the employ of Herbert Coppell often occupied homes near Front Street (now Dean Drive) or Engle Street. Thomas Faley was listed in Tillotson's directory of 1901 as the overseer of the poultry at the Coppell estate. Other Faley family members were gardeners for the Coppells. In the photograph at left, Thomas and Catherine Faley pose outside their house on the grounds of the estate. Below, the Faley family poses for a fun portrait. (Courtesy of John McNamara.)

Seven

DOWNTOWN

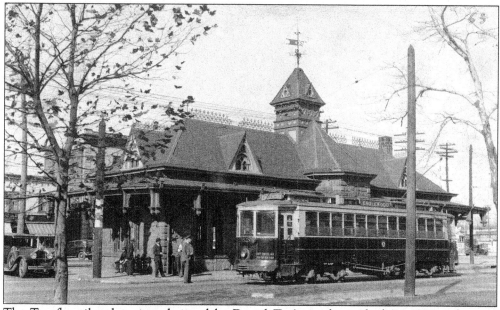

The Tenafly railroad station, designed by Daniel T. Atwood, was built in 1872 and served the community for more than 90 years. The train, which first came to Tenafly in 1859, made connections with ferries on the Hudson River. Daily, 44 trains ran through Tenafly. The station was listed on the New Jersey Register of Historic Places in 1978 and placed on the National Register of Historic Places in 1979.

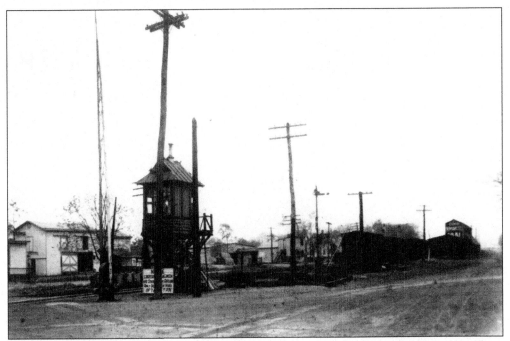

The railroad watch tower stood at the Railroad Avenue crossing near Hillside Avenue. Visible in this 1912 photograph are some early frame buildings on Railroad Avenue, a dirt road at the time. Edwin Demarest's coal storage building is seen to the north along today's Piermont Road.

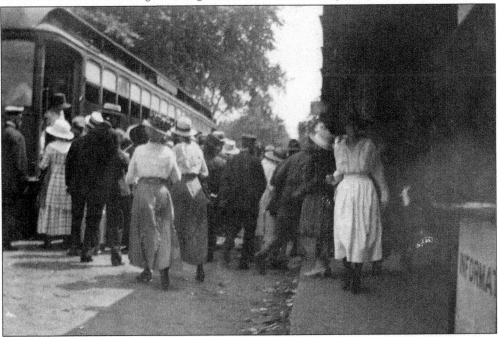

The trolley came to Tenafly after 1910. Its route terminated at the east side of the railroad station. The trolley tracks ran west of the Clinton Inn along what was called Front Street (now Dean Drive) and parallel to the railroad tracks. White rings on poles indicated where other trolley stops were. (Courtesy of John McNamara.)

This photograph shows the view south on Dean Drive from Westervelt Avenue in 1938. The former Coppell estate grounds would be approaching on the left since the photograph was taken before the area was developed for housing. The tracks were located to the right of the telephone poles. (Courtesy of Joyce Zeiller.)

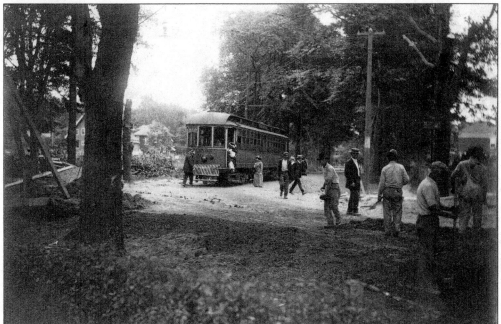

This view of passengers embarking the trolley is from about 1910. The trolley is seen coming north on Front Street. Trolley service was fast and cheap with a car coming every 20 minutes. The last trolley ran in May 1937, at which time bus service was well established. (Courtesy of Bob Fuller.)

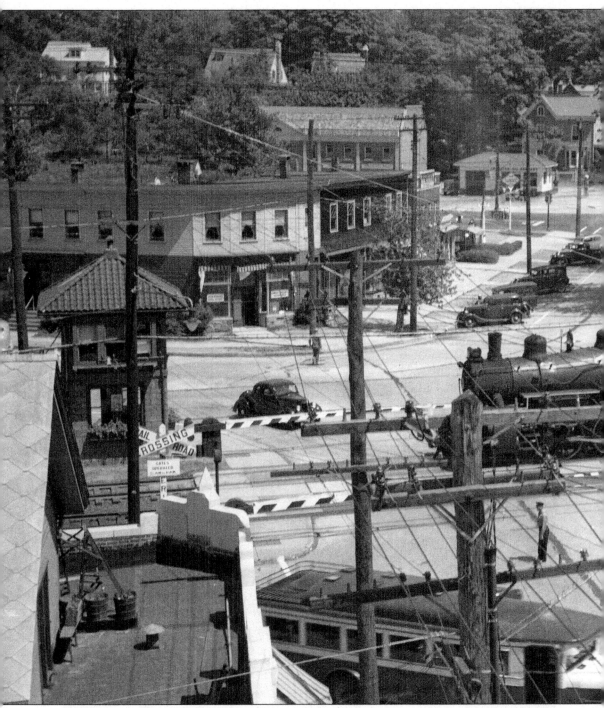

From the vantage point of the Washington Street Apartments, one can get a good look at the goings on in 1935 Tenafly. The train carrying coal heads north toward the Demarest coal yard. Cars are parked diagonally along Hillside Avenue, and the garden in front of Helen Oakley's store is visible. Jack's Diner was just past Oakley's gift shop and DiLeo's tailor shop. On this corner of Hillside and Highwood Avenues was where Norbert Pendergast II sold Christmas trees

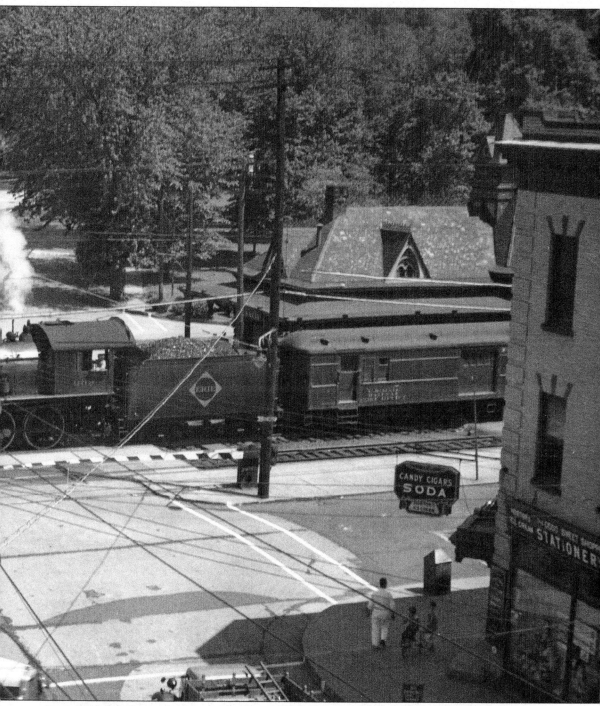

every year. Moe's gas station, at the foot of Hillside Avenue and County Road, is just south of the Tribune building. An early bus is shown—commuter service began when the George Washington Bridge opened in 1931. There were no traffic lights here; the police directed the traffic downtown.

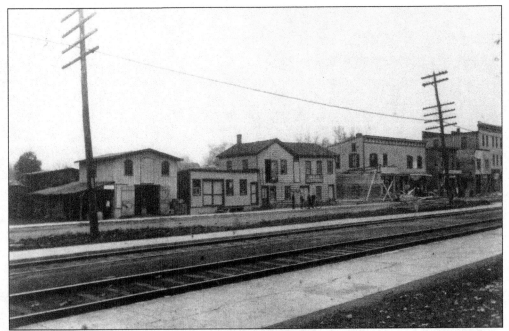

This view of West Railroad Avenue from about 1912 shows a mix of buildings still standing with some that are a distant memory. The Atwood shop was one of the frame buildings on the southern end now roughly where the movie theater stands. The Bower (also known as Oddo) building is at the end of the block farthest to the north.

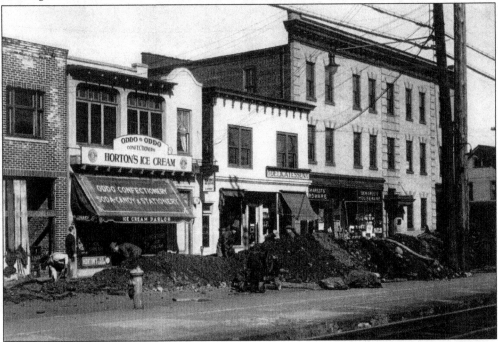

The development and progress of the commercial area near the railroad station made it necessary that new sidewalks be installed. This photograph of West Railroad Avenue was taken approximately in 1915.

This is Andy Knox's barn on West Railroad Avenue about 1910. Knox was a prominent figure in the Tenafly commercial district. In addition to the barn shown in the photograph, Knox purchased the general corner store from the Fowler family about 1900. Knox was instrumental in establishing an early Tenafly Chamber of Commerce. He eventually became a Bergen County freeholder in the 1930s.

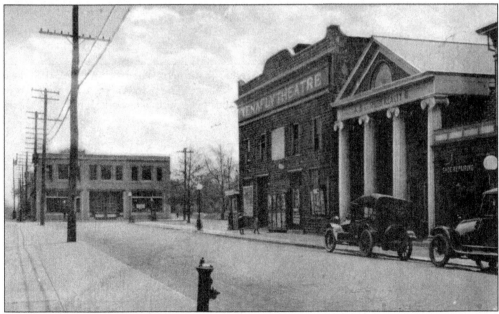

Built about 1915, the Tenafly Theatre is shown here with its original brick front. It was renovated in 1926, and the current facade was added at that time. Back in 1921, the owner was informed that an ordinance would discontinue the showing of moving pictures on Sundays. The movie being shown at that time was *The Mystery of Mr. X*, with Robert Montgomery. The theater was eventually known as Bergen Photo-Plays, then the Bergen Theater, and now Tenafly Cinema 4.

A young gentleman walks south on Railroad Avenue about 1916. The Horton's Ice Cream logo on the awning of Oddo's sweet shop is seen in the distance. The man is approaching a pillar in front of the K. B. C. Smith building, which still stands but houses a law office and some shops. Smith was the developer of the Old Smith Village.

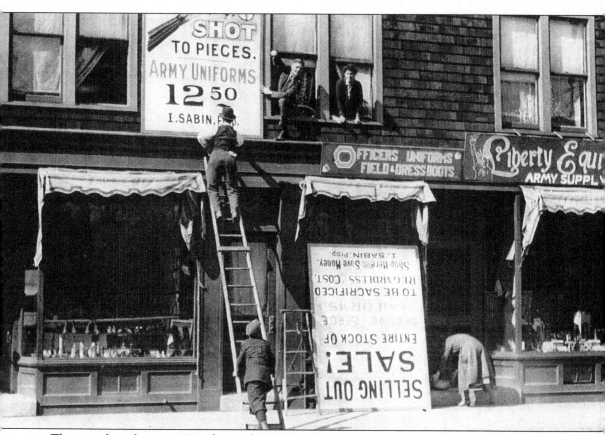

The sign above longtime Tenafly merchant Ike Sabin's store is in the process of being changed. The movie theater was a few doors to the left of this photograph. An army-navy store, popular during World War I, was found on this same block at that time.

This is a portrait of George Coyte, longtime proprietor of Coyte's variety store on West Clinton Avenue. Coyte's son Chris also opened a retail store on Railroad Avenue. Coyte's store was eventually demolished for the expansion of the Tenafly Trust Company bank.

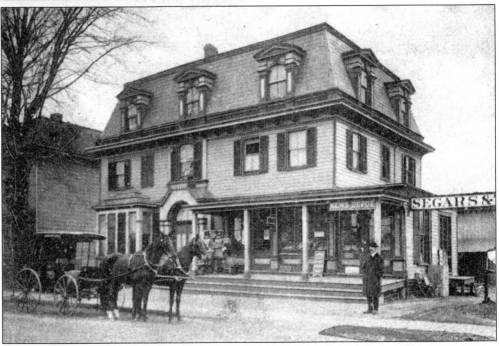

Shown on the corner of Clinton Avenue and Railroad Avenue is Coyte's old general store, where the passing schoolchildren used to stop to buy penny candy. This variety store also sold newspapers, tobacco, ice cream, and, early on, fireworks.

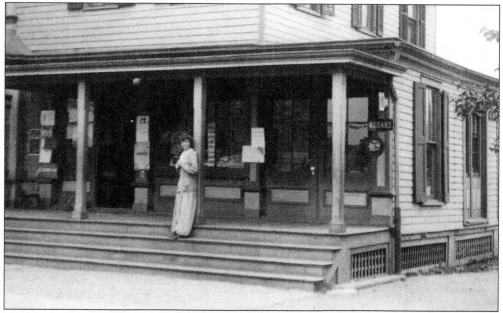

This is Amelia Springer Hobby standing in front of Coyte's store about 1910. The Springer family came to Tenafly in 1876 and lived for many years at 69 Hillside Avenue. Hobby's mother was Louisa Coyte Springer, a daughter of George Coyte, the founder of this popular convenience store. Hobby was born in 1893 just before the borough was formed and was still in Tenafly to celebrate the town's 75th anniversary in 1969.

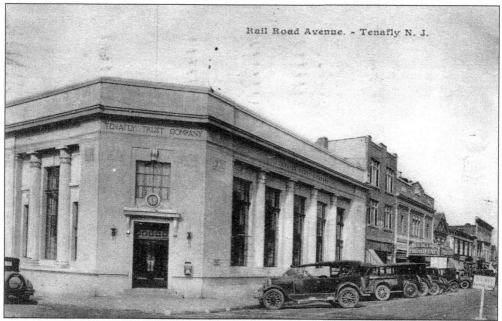

The Tenafly Trust Company bank building, constructed between 1920 and 1922 and later expanded, is still a prominent landmark in town today. The rest of the buildings on West Railroad Avenue visible in this 1933 card looked much the same as they appear in modern times. (Courtesy of Paul J. Stefanowicz.)

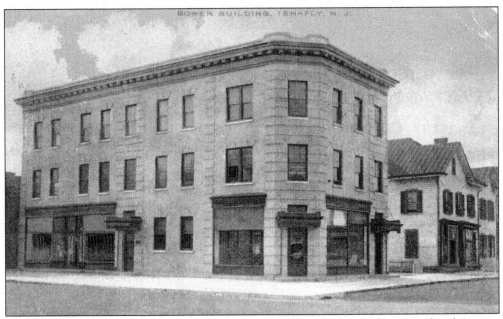

Built for Edwin I. Bower, the Bower (also known as Oddo) building at 13–15 Railroad Avenue was designed by Nelson K. Vanderbeck of Englewood and constructed by Charles S. Demarest of Bergenfield. The cornerstone was laid on October 25, 1911. The post office was in the building from 1912 to 1929. The building was sold to Salvatore Oddo and is still referred to by old-timers today as Oddo's sweet shop.

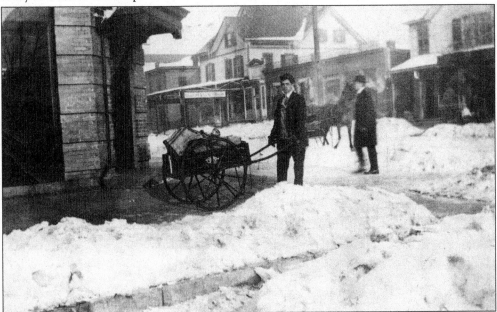

This 1920 photograph of a snowy day on Washington Street reminds one of the blizzard of 1888, which caused snowdrifts up to 20 feet high, preventing the trains from getting through town for three days. Being self-sufficient in those days, residents survived quite well with their own barrels of sugar, flour, dried fruits, and meats, while making their own bread and carrying well water to their houses.

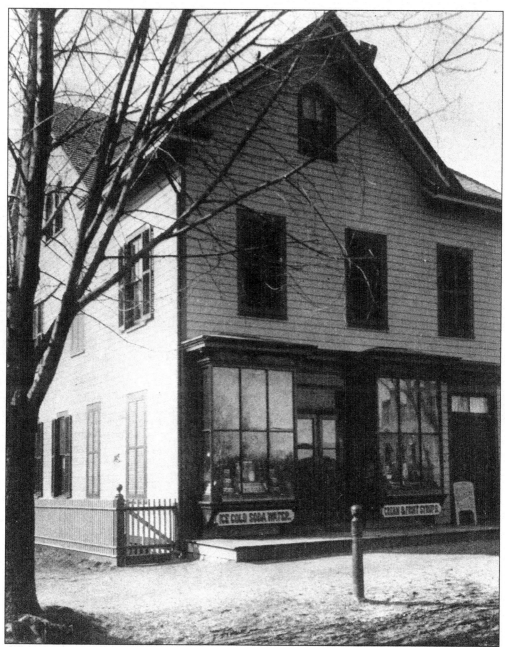

Shown is the first Bower's Pharmacy store on Washington Street after it moved from Watson's Row in 1884. The shop moved to its final destination one door to the east, and this building was demolished. The Watson's Row shops were located on Highwood Avenue west of County Road. John Watson owned a shoe store and was a pioneer in early orthopedic shoes. David and Andrew Watson ran a grocery and feed store. Besides Bower, George Coyte also got his start in a shop in Watson's Row. The vote to determine the independence of Tenafly as a borough was held at Watson's Row.

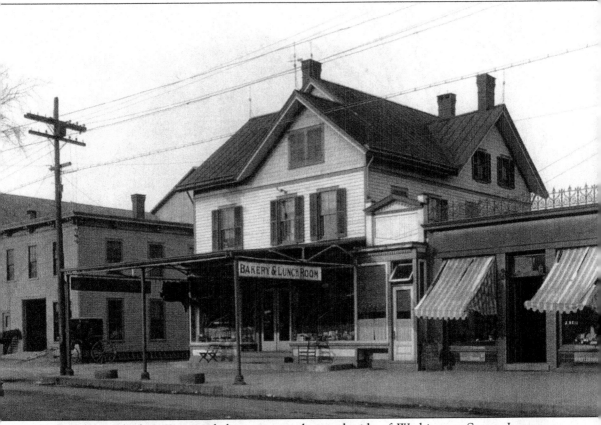

C. L. A. "Charlie" Wenger's bakery was on the north side of Washington Street. It was a combination bakery and luncheonette. At the dawn of the 20th century, Wenger's advertised "all kinds of pies, cakes, Vienna French and Milk Rolls," along with its celebrated Washington cream bread. Ice cream could be purchased at Wenger's by the gallon, quart, pint, or plate. The Washington Street Apartments building now stands in its place.

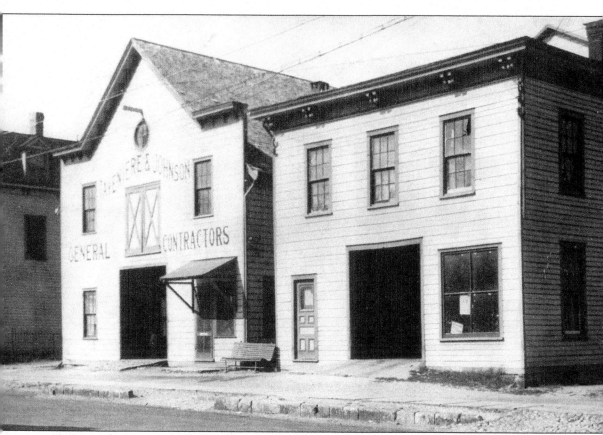

To the west of Wenger's bakery on Washington Street stood the livery stable of James Taveniere and Darius Johnson. As a companion location to the Closter business, Taveniere and Johnson did mason and excavation work on many local projects, including the Browning School. The stable is also where horses and carriages were kept by owners or available for rental. On December 24, 1924, the buildings were destroyed by fire in perhaps the downtown's most notorious blaze. Ironically, the strip of stores that replaced Taveniere and Johnson was also destroyed by fire. This location later became the Tenafly home of Gristede's and later CVS.

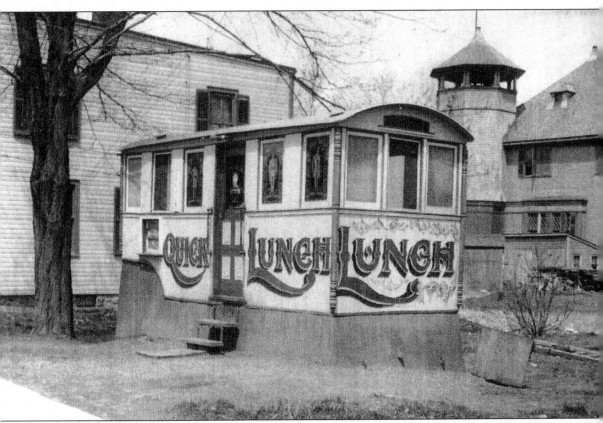

Tenafly's Quick Lunch Diner was located on lower Hillside Avenue near the Converse building. The diner was actually a cart that was fixed in place. Jack's Diner later stood in roughly this same spot. Tenafly Hall is visible behind the diner on Highwood Avenue. This photograph was taken about 1915.

Hyman Katz had a clothing store on Washington Street in the early 1900s. He advertised "Ladies' and Gents' Furnishings, clothing and caps. A full line of up-to-date hats, and Arrow Collars." This picture dates back to around 1915.

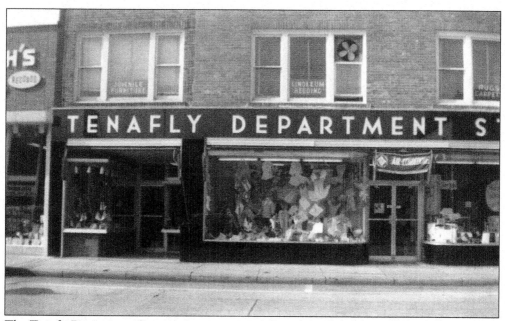

The Tenafly Department Store was an institution in town for decades, located on the south side of Washington Street. Clothes, shoes, and accessories for all ages were available in one place right in downtown. Many mothers took their children to the department store in anticipation of a new year. The store closed its doors for the last time in 1997, when its last owner, Milton M. Hart, retired.

The Valley Hotel (now Charlie Brown's Steakhouse) appears to be the location of the 1880 vote where Elizabeth Cady Stanton attempted to participate. During the Depression, local ladies worked as seamstresses in the dress factory located in the back of the building. There was a bowling alley beneath the factory; in later years, some wooden bowling balls were found. A bar was located in the front. A horse's hitching post was outside until recent years. (Courtesy of Paul J. Stefanowicz.)

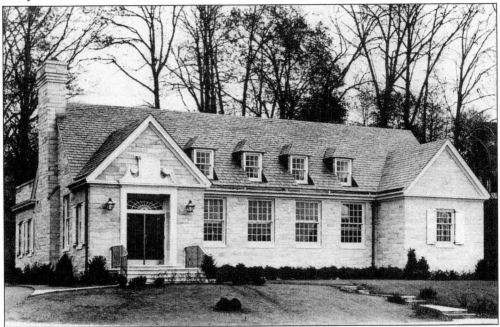

Today's NVE Bank, located at 80 County Road, traces its roots back to the Tenafly Building and Loan, which was incorporated in 1905 while located in the Demarest building. This building opened in 1941. Originally a lending institution only, the bank established a savings account system in 1947.

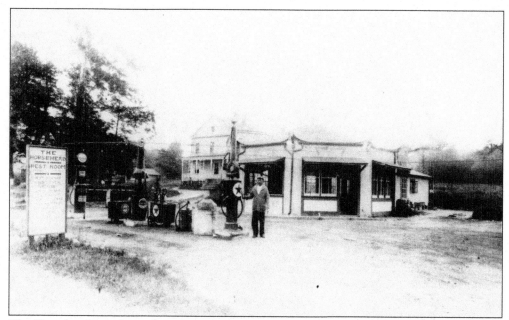

The Horsehead was located at the corner of Hudson Avenue and County Road. It was well known for the cutout decorative horse heads that ran around the roofline. During the 1920s, it was a gas station that also sold ice cream and snacks. Fireworks were for sale here, and there was a miniature golf putting course next to it. Eventually it became a tavern called the Well that was still in business into the 1940s.

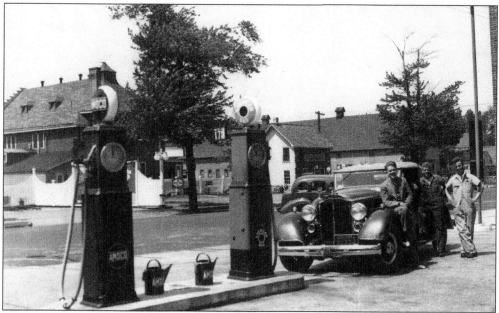

The Amoco station was found on the corner of County Road and Hillside Avenue. Shown from left to right in this 1936 photograph are Bill Agnew, Stuart Kessler, and Milton "Moe" Leahy. The station eventually belonged to Leahy for decades and was known as Moe's. Across the street is the back of Tenafly Hall and a former lumber warehouse/stable. Leahy's garage was later demolished and the filling station reconfigured.

The Tenafly Free Library Association was formed in 1909. In 1912, this building, formerly the post office, was moved from the corner of Railroad Avenue and Washington Street farther west on Washington Street. It opened as the library in March 1912. This photograph was taken soon after the library's opening. This library was later expanded four times before it was demolished in the early 1960s.

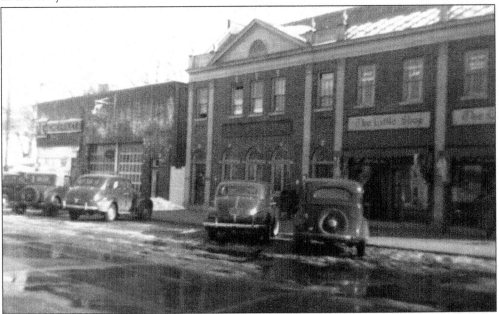

This is a 1930s picture of the Tribune building. The *Northern Valley Tribune*, the local weekly newspaper published in Tenafly, had its editorial office on the second floor. To the right were the Little Shop dress stores. The post office was in the center part, having moved to this spot from the Bower/Oddo building. Previous to the Bower building, the post office was located at the railroad station and in a freestanding frame building outside the Bower location.

Eight

THE FAMILIES AND
THEIR BUSINESSES

Col. Abraham Garrison Demarest
(1830–1900), a Civil War veteran,
commanded a regiment that was part
of the 22nd New Jersey Volunteer
Infantry. After his military career was
over, Demarest set up a retail business
in Cresskill. About 1870, Demarest was
invited by Tenafly representatives to move
his business to Tenafly. Demarest did so
and purchased a prime triangular lot on
lower Highwood Avenue.

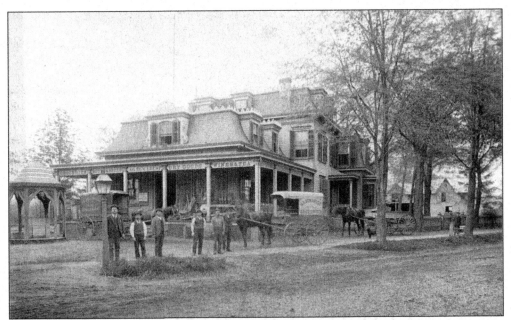

Pictured here is the early storefront of Demarest's in the mid-1880s. The Demarest family lived in the house behind the business. Demarest's sold dry goods, hardware, groceries, and coal. The delivery wagon was driven for many years by Richard Delehanty of Railroad Avenue. Several of Col. Abraham Garrison Demarest's children (and eventually grandchildren) became involved in running various departments of the store, which kept the business in the family and running for over 120 years. (Courtesy of Tom Swift.)

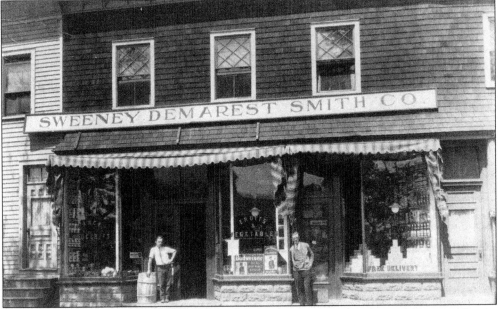

One son of Demarest was Clifford, known more for his role as a music instructor. For several years during the second decade of the 20th century, Clifford and his brother Roy ran a small grocery store on Hillside Avenue. After competing with Sweeney and Smith for some time, Demarest went into business with them. They advertised themselves as "Professional Food Merchants."

Demarest's daughter Amy Demarest Cattelle ran a gift department in the store for over 30 years. A lifelong Tenafly resident, she lived to the age of 102. Shown in 1900 are her children Stanley (left) and Edgar Cattelle, who followed in running Demarest's store. Stanley Cattelle became mayor of Tenafly in the 1950s and was very involved in the Tenafly Volunteer Fire Department.

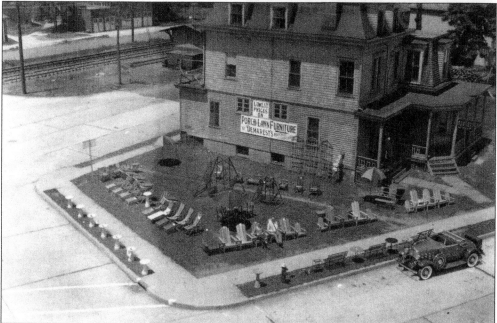

In 1914, Demarest's, then run by the founder's son Roy, was destroyed by fire. Arson was suspected. Demarest's business split into two other locations at that time—hardware was sold in a shop on Railroad Avenue, and housewares were sold in the former Tenafly Hall. This photograph shows Demarest's after the destroyed storefront had been cleared.

Col. Abraham Garrison Demarest's son Edwin ran the coal and feed departments of Demarest's retail business. The coal yard and storage areas were located behind the family's house on the same lot where a grocery market is found today. When Edwin Demarest died, his son-in-law Warren Swift took over the fuel business. Swift is shown in front of the fuel office above. Below are men working in Demarest's coal yard in the early 1900s. Coal was sorted according to size and available for on-site purchase or delivery. The horse-drawn wagon made deliveries into the 1920s. A chute was usually placed from the wagon down into the customer's basement through a cellar window, and the coal ran down into the waiting bins. The fuel business later moved to lower Hudson Avenue before being sold in the 1950s. (Courtesy of Tom Swift.)

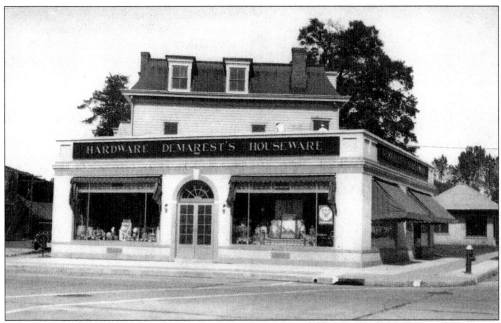

In the late 1930s, the Demarest family decided to rebuild the storefront in its former location. This united the retail businesses under one roof, and the remote locations were closed. Although the storefront was subsequently remodeled in later years (below), Demarest's business ran in this location under descendants of the colonel until it closed its doors for the final time in the mid-1980s. The building is now known as Demarest's Plaza, containing several stores.

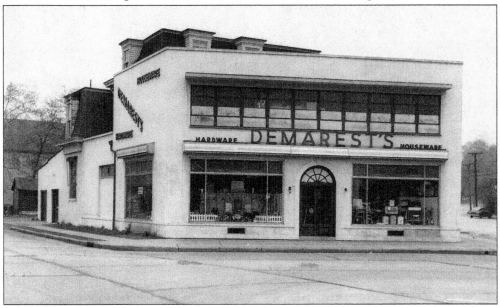

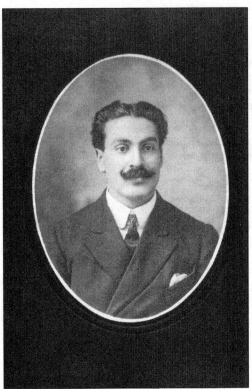

Rosario Curione, known as Russell, opened a shoe store on Washington Street in second decade of the 20th century. With his earnings, Curione was able to buy other properties in town during the Depression, when the economic squeeze made prices more favorable. The Curione family eventually purchased the Corner Store building, where they lived, of which the roofline remains a familiar part of Tenafly's landscape. After Curione died, his brother Peter took over the shoe business. (Courtesy of Angie Curione Zwisler.)

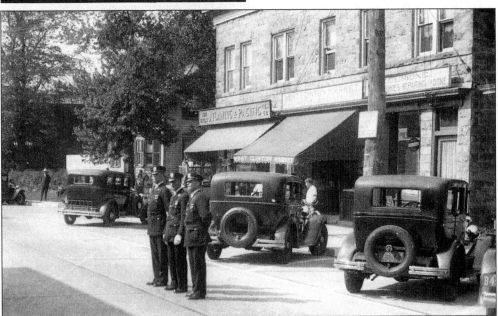

At 29 Washington Street is the early A&P, the West Clinton Market, and Curione's shoe store in the 1920s. The building was constructed by Curione and still stands today. The house in back with people on the porch was the late mayor Byron Huyler's old homestead. It stood on the corner of Washington and South Summit Streets near the old borough hall. In 1940, this landmark home was demolished.

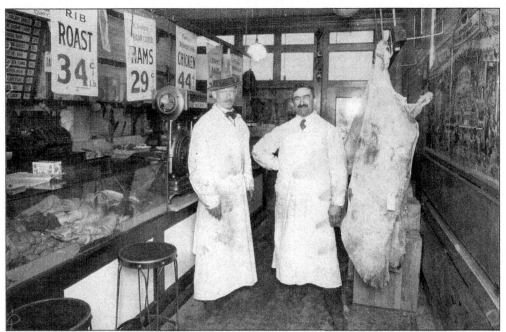

About 1910, Philip Mildenberger (left) and his partner, a Mr. Scheffler, are pictured in their Railroad Avenue butcher shop, called the West Clinton Market. Later, when Mildenberger became sole owner, he moved the business to Washington Street into the Curione building. Mildenberger and Scheffler had additional shops in the Highwood area of Englewood and in Cresskill. (Courtesy of Ellie and Edward Mildenberger.)

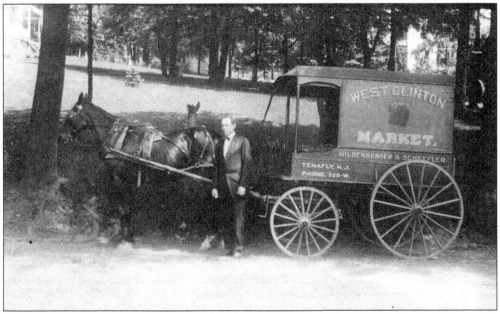

Mildenberger is dressed for business, making deliveries from his West Clinton Market. He came to America with his two brothers and their father, Valentine, and lived for a while in Upstate New York before moving to Tenafly. There were also Mildenbergers in the butcher business in Jersey City. (Courtesy of Ellie and Edward Mildenberger.)

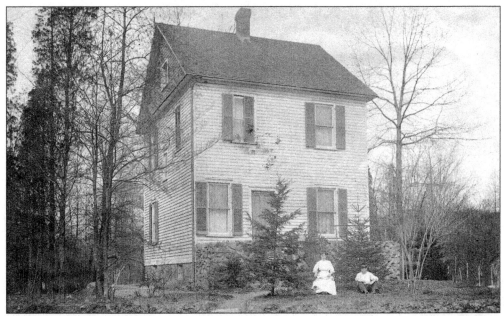

Sophie and Philip Mildenberger are pictured at home on Highwood Avenue about 1914. This house was originally next to the Elizabeth Cady Stanton house and later moved to the east. Through many changes, it remains today at 157 Highwood Avenue. In later years, the Mildenbergers built a new house at 49 Glenwood Road and moved there prior to 1923. (Courtesy of Ellie and Edward Mildenberger.)

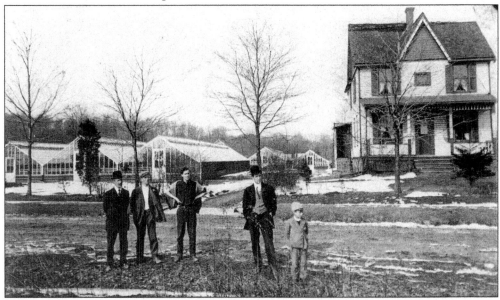

This 1910 photograph depicts the Burrows Greenhouses operation on Columbus Drive. Shown from left to right are Edward Burrows (proprietor), an unidentified employee, William Burrows, Edward Burrows Jr., and Jack Burrows. The greenhouses were built between 1895 and 1900, with the principal crop initially being violets supplied to the perfume trade or sold wholesale. The business grew over three generations, continuing until 1985 when the last Burrows son, Robert, retired.

Emil Karsten (1890–1964) was born in Hamburg, Germany. He joined the German Merchant Marine before coming to New York to work in city hotels. He bought the Clinton Inn in 1922 and married his wife, Lydia, in 1925. She was also from Germany and came to Tenafly to cook for a doctor. Their daughter Ruth Karsten graduated from Tenafly High School in 1945. (Courtesy of Irmgard Merk Hartung.)

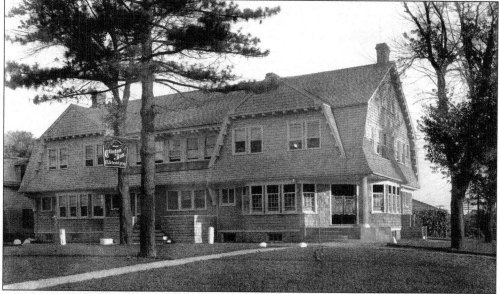

In the 1870s, the Clinton Hotel served as a tavern and restaurant. After a fire destroyed the original building (shown above) in 1907, a new hotel was opened the following year by Leonard Schenkel. In 1922, Karsten bought the popular dining spot and tavern, which he operated until 1948 when the Chagaris brothers purchased it. The 1908 building was demolished in 1978 after 70 years of operation. The Clinton Inn Motor Hotel was built in 1968. (Courtesy of Bob Fuller.)

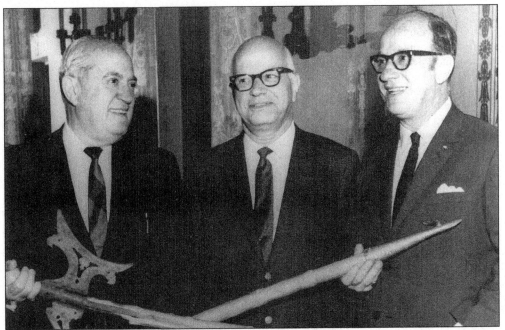

Shown above from left to right, the Chagaris brothers, Peter, John, and James, bought the Clinton Inn in 1948. They immediately hired nationally known restaurant architect Francis Keally to redecorate and reequip the building. A brand-new fully tiled stainless steel kitchen was installed. At this time, there were 14 guest rooms in the inn and 9 more in the annex building. (Courtesy of Athena Chagaris.)

Real American cooking was now emphasized to match the inn's Colonial atmosphere. The dining room accommodated 200, and the taproom sat 50. In 1978, this popular landmark was replaced by a new, modern hotel, with 119 guest rooms and dining facilities for 700. The Clinton Inn continues to serve the community today and is enjoyed by visitors from all over the world. (Courtesy of Athena Chagaris.)

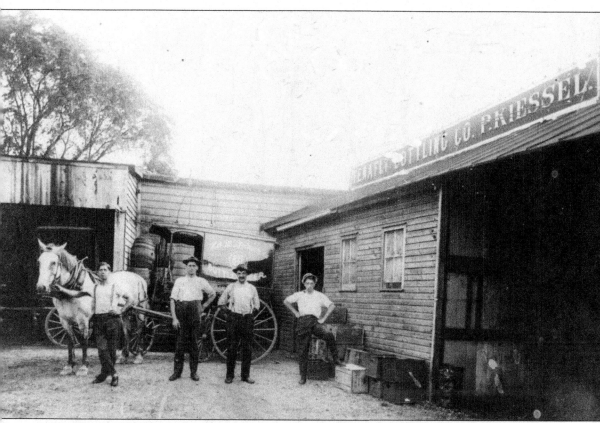

The Tenafly Bottling Company is pictured here in the early 1900s. Around 1900, this bottling works, owned by the Kiessels, was located behind the old Clinton Inn while the family lived in the old Huyler house on Front Street. The Kiessels owned the first Mac truck used for deliveries after the horses were retired. The Schackels, Ludwig Mayer, and Garsches also owned bottling works, located in 1903 on County Road near Central Avenue. Originally the beer was delivered in bottles from breweries around Harrison (Jersey City), but the rough roads and horse-drawn carts caused too much breakage. Soon, being the entrepreneurs that they were, they brought barrels and bottled here in Tenafly.

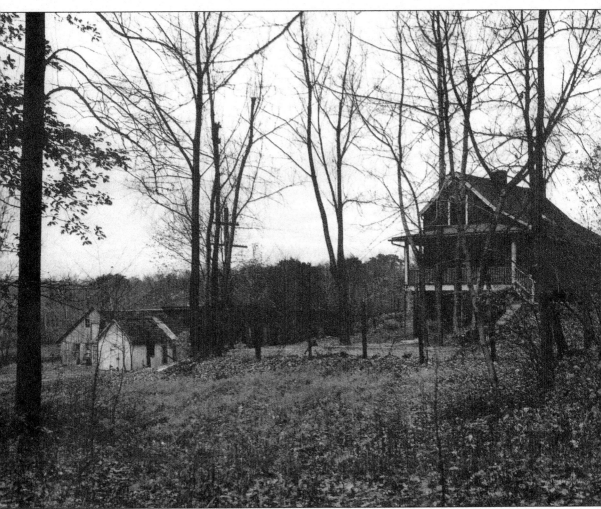

Highland Dairy was a 13-acre farm run by David Breen from 1900 to 1928. It was found along modern-day Bliss Avenue in part of an area known as Highwood at the time it operated and now regarded as Tenafly. Highland's location brought in customers from Tenafly and Englewood. (Courtesy of Helen Moore.)

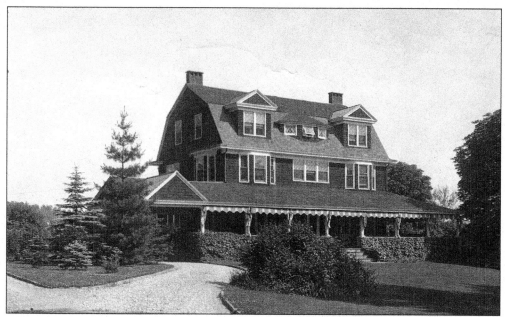

The W. K. Everdell house was built on Engle Street about 1908. Everdell's wife, Jennie Grannis Everdell, wanted to be near her family on Hudson Avenue's Bonny Dell Farm. W. K. Everdell was one of the founders of the Knickerbocker Country Club. After he died, the property was sold and the house demolished. As a widow, Jennie Grannis Everdell moved to the Bonny Dell property close to her family. (Courtesy of Suzanne Mugler.)

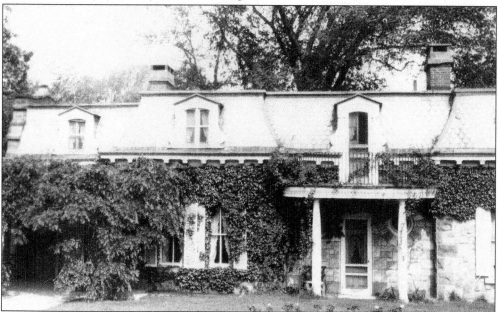

This house at 177 Hudson Avenue was where the Grannis family, proprietors of Bonny Dell Farm, lived. The house, built in the 1870s, is located on the western part of what was originally a five-acre tract of land, formerly part of the Sir James Jay farm. The house and grounds were previously owned by the Anthony family for decades before the Grannis family purchased them about 1905. Descendants of this family own it to this day. (Courtesy of Suzanne Mugler.)

After his father Grosvenor Grannis died, Grosvenor Grannis Jr. managed Bonny Dell Farm from the late 1920s into the 1950s. By that time, the farm was a distributor for Ideal Dairy. He lived on the Hudson Avenue property and raised three children in Tenafly before retiring to Florida. (Courtesy of Suzanne Mugler.)

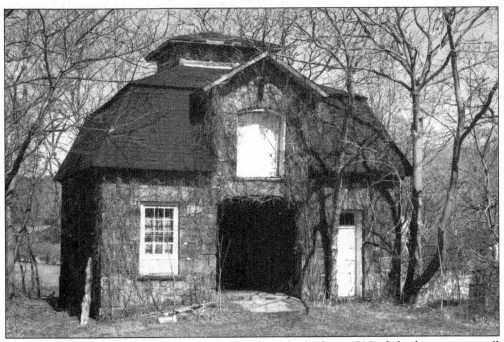

The barn on Bonny Dell Farm appears to have been built about 1795 while the property still belonged to Sir James Jay, brother of Supreme Court justice John Jay. In later years, the Grannis family used it to store hay, which was lifted by the winch, shown in the photograph, up to the loft. Since 1977, it has served as a private residence on Peter Lynas Court. (Courtesy of Rosemarie and Don Merino.)

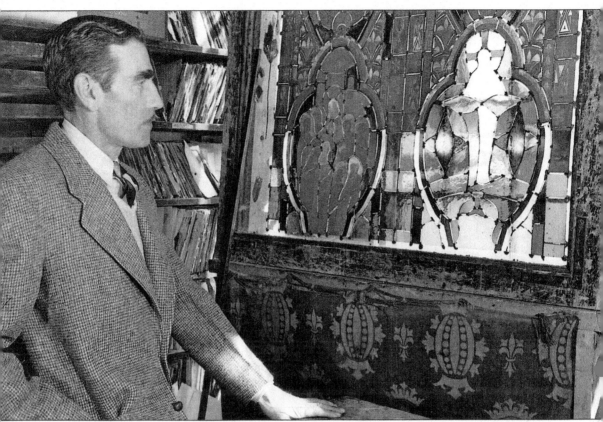

The J and R Lamb Studio was America's oldest stained-glass producer and was world renowned for its religious art. It was represented in cathedrals, colleges, museums, and innumerable churches, including those in Tenafly. Col. Karl Barre Lamb, head of the Lamb Studio, is shown above in his office alongside one of the stained-glass windows. After 80 years in New York City, the business was located on West Clinton Avenue in Tenafly from 1932 to 1956, and later it could be found on County Road from 1956 to 1970. In 1957, the Voice of America broadcast the story of the business to 47 countries. Today the entire collection of original designs resides in the Library of Congress. (Courtesy of Barea Lamb Seeley.)

Shown in 1920, the Tenafly Tennis Club, formerly the Tenafly Country Club, stands alone west of the woods among fields of grasses just north of the intersection of Glenwood Road and Highwood Avenue. Houses on the north side of Highwood Avenue ended at Glenwood Road. In the early years, a water line ran from the Mildenberger house on the west side of Glenwood Road, supplying water to the club.

The street signs might have been there but not much else. Where the Tenafly Post Office and its parking lot now stand, some early houses on South Summit Street and a building on Riveredge Road in the distance are identified.

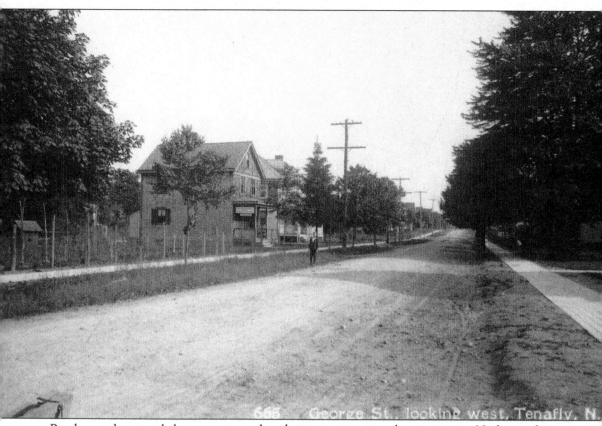

666 George St., looking west, Tenafly, N.

Roads were less traveled a century ago, but their purpose was no less important. No longer do dusty shoes and muddy boots traverse these roads, and no horses' hooves clop-clop or wagon wheels creak along the worn ruts in the dirt. The lives that passed this way before and paved the roads with their deeds are remembered. Their days and their special contributions are celebrated and enjoyed by today's residents, and in this way, one can come to live comfortably with the past.

Visit us at
arcadiapublishing.com

CPSIA information can be obtained
at www.ICGtesting.com
Printed in the USA
BVOW07*0743150118

505270BV00018B/320/P